AVANT-GARDE
GAMBITS
1888/1893

THIS IS THE TWENTY-FOURTH OF THE
WALTER NEURATH MEMORIAL LECTURES
WHICH ARE GIVEN ANNUALLY EACH SPRING ON
SUBJECTS REFLECTING THE INTERESTS OF
THE FOUNDER
OF THAMES AND HUDSON

THE DIRECTORS WISH TO EXPRESS
PARTICULAR GRATITUDE TO THE GOVERNORS AND
MASTER OF BIRKBECK COLLEGE
UNIVERSITY OF LONDON
FOR THEIR GRACIOUS SPONSORSHIP OF
THESE LECTURES

AVANT-GARDE GAMBITS

GAMBITS

1888-1893

GENDER AND THE COLOUR
OF ART HISTORY

GRISELDA POLLOCK

THAMES AND HUDSON

Printed and bound in Great Britain

978 0500 550250

I have to express my deep sense of honour at being invited by Mrs Eva Neurath and her family to give the 1992 Walter Neurath Memorial Lecture. It is an extremely distinguished cast that I join, and I feel duly awed by the eminence of my predecessors — and a little lonely. The honour is made even more special by my being only the second woman to join this remarkable roll-call from art, art history, history, architecture and philosophy. I must hope that what I have to say does not make me the last.

My thanks also go to Lady Blackstone and Birkbeck College for jointly hosting an event that was both challenging and pleasurable. New forms of knowledge and critical engagements with familiar stories are necessary to ensure that we never become complacent and mistake what is normal and familiar for 'truth'. Serious argument undertaken in a genuine concern to understand ourselves as well as our world should, however discomforting, be a source of pleasure.

Lastly, I want to thank my husband and children. Without their support and tolerance I could not imagine doing my work.

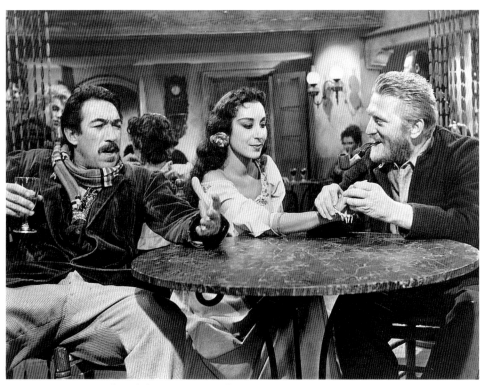

1 *Lust for Life* (Vincente Minnelli, MGM, 1956). *Left to right* Gauguin (Anthony Quinn), Rachel (Julie Robinson), Van Gogh (Kirk Douglas). As this scene progresses, Rachel withdraws her attention from Van Gogh and offers herself to Gauguin. He casually accepts her inevitable submission while continuing to expound on the joyful release he finds in physical violence.

IN 'LUST FOR LIFE', Vincente Minnelli's film of 1956, Paul
Gauguin (Anthony Quinn) and Vincent van Gogh (Kirk Douglas)
go to the fashionable downtown Café du Forum for a drink and do what
men do in this situation: watch women and pass comments. While Van
Gogh admires the grace and stately beauty of the renowned Arlésienne
women, Gauguin exclaims in disgust:

I'm talking about wimmen! I like my women fat, vicious and stupid with
nothing spiritual. To say I love you would break my teeth.

With this – a direct quote from Gauguin's journals – off his chest,
Gauguin demands to be taken to a livelier part of town where he
delightedly joins in a therapeutic street brawl, before entering a brothel.
There Rachel (Julie Robinson), evidently Van Gogh's special com-
panion, subtly transfers her attention to the compelling and masterful
Gauguin in a scene which confirms the dominating and primal maleness
'Gauguin' signifies within the complex discourse on modern art and the
modern artist staged by Minnelli's sophisticated movie.[1]

In the persona of Quinn's 'Gauguin', *Lust for Life* dramatizes the
gendering of modern art and its making. There is no lack of evidence of
the intimate connections between ideas of the artistic vocation and
masculine sexuality in the late nineteenth century, from Flaubert to Van
Gogh, including Gauguin himself. As Carol Duncan has so clearly
demonstrated, modernism was an enunciation of masculine sexuality
signalled both literally and symbolically through the relations of 'man the
artist' to 'women *in*, and *of*, the city' as both sexual prey and artistic

cipher.[2] As popular culture, Minnelli's representation of modernism's formative moment uses the character of Gauguin to avow the symbolic importance of masculine sexuality in the mythologies of modern art. The discourses of high culture such as art history, however, are more reticent and ambivalent and hence more implicated. Art history appears to repress the questions of gender, sexuality and sexual difference while collaborating with patriarchal versions of all three through its uncritical celebration of great masters and its vicarious identification with the sexualities of the art and artists it canonizes in the pantheon of Post-Impressionism.

The work of Paul Gauguin, I suggest, supplies the fantasy scenarios and the exotic mise-en-scène for not only masculinist but also imperialist narratives. Gauguin, like Picasso, is regarded as a major father of modern art, a term rich in both reproductive and sexual connotations. He is usually perceived as having revolutionized Western art by rejecting the etiolated civilization of Europe and its cities by seeking to reconnect with basic human sensation, impulses and feelings in a rural paradise. Such a Utopian project could only be attempted, however, in an imaginary world named 'the Tropics', which had, nonetheless, a material foundation in concrete social spaces, redefined by colonialism.[3] Personal liberation through an unfettered sexuality and aesthetic refreshment through an appropriative and exploitative multi-culturalism – what the modernizing Europeans termed 'primitivism' – are part and parcel of this nineteenth-century myth of the tropical journey.[4]

How does a European woman position herself, therefore, in relation to this history and its art histories? Am I obliged to adopt the forms of professional transvestitism normally required of women scholars and either masochistically identify with the image of my own objectification mediated through the demonizing appropriations of non-European cultures or displace my interest onto formal concerns which provide what Freud called 'the surplus of aesthetic beauty?'[5] Can I call upon the discourse and politics of international feminism to interrupt these impossible positions, to construct a critical and historical relation to the stories of modern Western art?

2

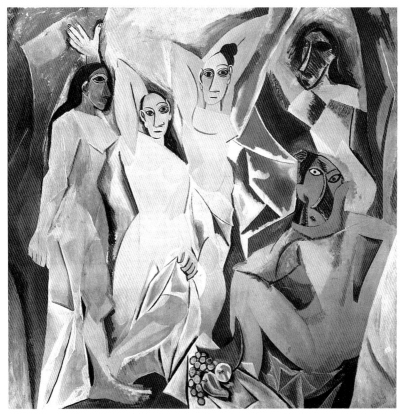

2 Picasso, *Les Demoiselles d'Avignon*, 1907. In this painting, set in a brothel in Barcelona, Picasso appropriated sculptural forms from ancient Iberian and contemporary African arts to represent the Western male intellectual's fantasy of access to a demonic, primal sexuality.

In a post-colonial era, no Westerner can be complacent about the late nineteenth-century conjunction of aesthetics, sexuality and colonialism. Although feminism supplies me with a critical distance from the masculinist narratives of modernism and its celebratory art histories, how can I resist the colonial assumptions embedded in those histories, and in myself, as a subject of the West? Black feminists have condemned the limited versions of what they call 'imperial feminism' which is itself part of a politics of racial domination.[6] What must I become in order to confront *both* the gender *and* the colour of art history and see their historical overlapping?

My provisional strategy is three-fold. First there is dis-identification, a Brechtian process of making the familiar stories strange through a critical reading of one paradigmatic painting and the historical context of its production. Then there is re-identification – as a feminist scholar with the historical Tahitian woman, a subject of her own history, who appears only as the object of representation in a Western art history. Teha'amana is known to us only through her historic encounter with the West, embodied in Gauguin, the colonial artist. Finally there is a theoretical revision of these relations of historian and text, historical femininities and masculinities, through the matrix of the Tourist, the paradigmatic mode of modernity in the age of high colonialism.

When I gave this paper as a lecture, there was a certain amount of discomfort, a sense perhaps of indictment directed at an audience from whose complicity with the colonialist and racist assumptions of art history I could set myself righteously apart. I want to make clear that this is not and cannot be the case. This study emerges out of a political and personal need to confront the issues of racism in art history. I am a product of the colonial era. I was born in South Africa of white parentage in a society committed to vicious and systematic racism and my early life was profoundly 'coloured'. At a banal level, my initial grasp of the physical environment was through the intense and memorable colours of the southern African light and landscape, which provided a setting for those quintessentially white colonial houses set off by the vivid blossoms of subtropical bougainvillaea and jacaranda. Learning to read by deciphering public signs, I found that the social landscape was also coloured. 'Whites Only' here, 'No Blacks' there; these were the pigments in which a racist hierarchy marked the environment in which I began to learn about the adult social world. Through the distorting lens of apartheid signifying white over black, which segregated national and cultural communities, I was taught a lexicon of power and privilege.

The injuries of racism cannot be made better by the privileged adopting a liberal stance towards those who suffered the system, by my 'concern' for those who worked for my parents and lost their social and cultural independence in order to service my family's domestic comfort. There is a work of deconstruction to be done which starts with naming

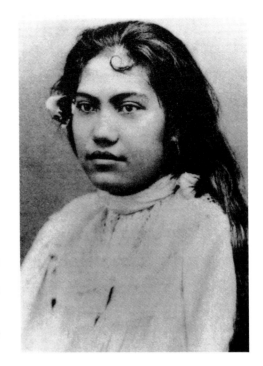

3 Photograph of
Teha'amana, who married
Paul Gauguin in Tahiti
when she was thirteen years
old. A provisional
identification (see ill. 50 as an
alternative possibility), this
photograph is included not as
a confirmed likeness, but as
an indication of
Teha'amana's existence, other
than in Gauguin's paintings.

the whiteness of power, a 'whiteness' which renders itself invisible by marking its exploited social and cultural others with excessive signs of difference. It is they who are coloured, black. Racism, as Adrian Piper, an Afro-American artist, has stated, is not her problem; it is mine/ours. This statement is also pertinent to those who suffer anti-semitism, as Jean-Paul Sartre revealed. But as a white colonial subject, of whatever cultural background, I must continually ask: What am *I* going to do about it? In his article 'White', film theorist Richard Dyer reversed the usual terms of analysis by not focusing on 'images of black people', but rather by making 'whiteness' the object of a critical reading of its 'cultural/historical construction, achieved through white domination'.[7] He argues that it is the invisibility of whiteness which allows it to colonize the norms of class, gender, heterosexuality, nationality and so on without itself being named as a category.

In a similar way, I am, in this project, turning the focus on my own position, using the mediating distance of feminist analysis to explore the possibilities of critical understanding of the structures within which I, as

a white art historian, have been formed, in order to produce a writing of art history which tries to find ways to achieve recognition of the historical subjectivity of a woman of colour. A critical reading of her situation, rather than a new mastery produced by telling *her* story in *my* words is tentatively offered as a means to create a distance between myself and the colour of art history. I invite my readers to share in this necessary project.

PARIS 1893

Reference, deference and difference
Paul Gauguin left France on 1 April 1891 amid considerable publicity equipped with letters from the Ministry of Public Education and the Fine Arts commissioning him to 'study and ultimately to paint the customs and landscapes of Tahiti'. On this French colony he hoped to be able to live cheaply and paint enough to support the intended resumption of his marriage to Mette Gauguin, mother of his five children, with whom he had not lived since 1887.[8] Almost immediately disappointed by Tahiti, Gauguin nevertheless spent two years there before he managed to persuade the French government to repatriate him. He landed in Marseilles – now penniless – on 30 August 1893.

By unexpected good fortune, he soon inherited from an uncle a small amount of money which enabled him to settle in a studio in Paris and prepare for a one-man show at the prestigious galleries of Paul Durand-Ruel. On 9 November 1893 the exhibition opened with forty-one canvases and two sculptures from his two years in Tahiti plus a few from his time in Brittany. The Durand-Ruel exhibition was not a financial success, since Gauguin demanded over-high prices. As a critical event, however, it was strategically important for him. Gauguin needed to regain a foothold in that fraction of the Parisian art world which we, in retrospect, call 'the avant-garde'. In his calculated career strategies, Gauguin was paradigmatic of avant-gardism of the 1880s/90s.

Avant-gardism involves a series of gambits for intervening in the interrelated spaces of representation, publicity, professional competition and critical recognition. By the 1890s, the spaces of avant-garde practice were wide-ranging, from the exhibition sites of the recently formed Salon

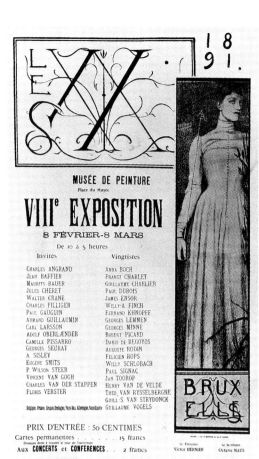

LE XX

MUSÉE DE PEINTURE
Place du Musée

VIIIᵉ EXPOSITION

8 FÉVRIER-8 MARS

De 10 à 5 heures

Invités	Vingtistes
CHARLES ANGRAND	ANNA BOCH
JEAN BAFFIER	FRANTZ CHARLET
MAURITS BAUER	GUILLAUME CHARLIER
JULES CHÉRET	PAUL DUBOIS
WALTER CRANE	JAMES ENSOR
CHARLES FILLIGER	WILLY-A FINCH
PAUL GAUGUIN	FERNAND KHNOPFF
ARMAND GUILLAUMIN	GEORGES LEMMEN
CARL LARSSON	GEORGES MINNE
ADOLF OBERLÆNDER	ROBERT PICARD
CAMILLE PISSARRO	DARIO DE REGOYOS
GEORGES SEÜRAT	AUGUSTE RODIN
A. SISLEY	FÉLICIEN ROPS
EUGÈNE SMITS	WILLY SCHLOBACH
P. WILSON STEER	PAUL SIGNAC
VINCENT VAN GOGH	JAN TOOROP
CHARLES VAN DER STAPPEN	HENRY VAN DE VELDE
FLORIS VERSTER	THEO. VAN RYSSELBERGHE
	GUILL.-S. VAN STRYDONCK
	GUILLAUME VOGELS

Belgique, France, Grande Bretagne, Pays-Bas, Allemagne, Scandinavie

BRUXELLES

PRIX D'ENTRÉE : 50 CENTIMES

Cartes permanentes 15 francs
Donnant droit à l'entrée au jour de l'ouverture

Aux **CONCERTS** et **CONFÉRENCES** . . 2 francs

Le Trésorier,
Victor BERNIER

Le Secrétaire,
Octave MAUS

4,5,6 By the late 1880s the outlets for avant-garde art included independent exhibition societies such as Les XX in Brussels (*left*). Exhibitions were also held in sympathetic magazine offices in Paris (*below*); or, as at the time of the Universal Exhibition in Paris in 1889, at a café near the showgrounds (*bottom*).

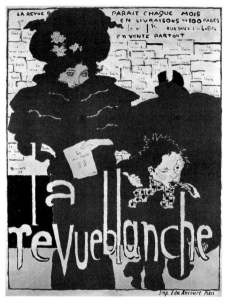

LA REVUE — PARAIT CHAQUE MOIS EN LIVRAISONS DE 100 PAGES — EN VENTE PARTOUT

la revue blanche

Imp. Edw. Ancourt, Paris.

GROUPE IMPRESSIONNISTE ET SYNTHÉTISTE

CAFÉ DES ARTS

VOLPINI, DIRECTEUR

EXPOSITION UNIVERSELLE

Champ-de-Mars, en face le Pavillon de la Presse

EXPOSITION DE PEINTURES

DE

Paul Gauguin	Émile Schuffenecker	Émile Bernard
Charles Laval	Louis Anquetin	Louis Roy
Léon Fauché	Daniel	Nemo

Paris. Imp. E. WATELET, 30, Boulevard Edgar Quinet.

Affiche pour l'Intérieur

Nᵒ 81

4 des Indépendants in Paris and the Salon des XX in Brussels to the
6 galleries of selected dealers and *ad hoc* exhibitions mounted in cafés and
 other places of entertainment, to the offices of specialist journals, to the
5 discursive spaces in daily newspapers and art magazines which
 advertised, reviewed and gossiped. These provided an informal network
 which was both fluid and yet sufficiently coordinated to provide a field of
 representation for the decisive character of avant-gardism: the play of
 reference, deference and difference.

This trilogy proposes a specific way of understanding avant-gardism as a kind of game-play. In contrast to conventional histories of modern art, which tell its story through heroic individuals, each 'inventing' his (usually) novel style as an expression of individual genius, I propose my three terms. To make your mark in the avant-garde community, you had to relate your work to what was going on: *reference*. Then you had to defer to the existing leader, to the work or project which represented the latest move, the last word, or what was considered the definitive statement of shared concerns: *deference*. Finally your own move involved establishing a *difference* which had to be both legible in terms of current aesthetics and criticism, and also a definitive advance on that current position. Reference ensured recognition that what you were doing was part of the avant-garde project. Deference and difference had to be finely calibrated so that the ambition and claim of your work was measured by its difference from the artist or artistic statement whose status you both acknowledged (deference) *and* displaced.

There is no better description of the conditions prevailing in the Parisian avant-garde in the late 1880s/early 1890s than that provided by the Belgian critic Emile Verhaeren in a review of the Salon des Indépendants published in 1891.

There is no longer any single school, there are scarcely any groups, and those few are constantly splitting. All these tendencies make me think of moving and kaleidoscopic geometric patterns which clash at one moment only to reunite at another, which now fuse, and then separate and fly apart a little later, but which all revolve nonetheless within that same circle, that of the new art.[9]

In the 1880s and 1890s the term avant-garde was not used.[10] From our perspective, however, I think we need the concept. It is not a synonym for

14

new or modern art. It defines a subculture. Furthermore, it is a structure for the production of art based on a series of chess-like moves: reference, deference and difference. It is a framework which generates and contains intense competitiveness, antagonism and ambition under a shared rubric. Verhaeren's image of the kaleidoscope is not attuned to individual careers. Rather it evokes the defining instability and discontinuities of this subculture's interventions as perceived at the time by the consumers of this new art. I have used the term gambits for these interventions, a term that not only suggests calculation but also implies a risk, a gamble.

It was not until the late 1880s that the institutional conditions for this game-play were in place. The informal arrangements of tentative and often irregular exhibition strategies associated with the loose confede-ration organizing the Impressionist exhibitions of 1874 to 1886 were formalized with the founding in 1884 of the Salon des Indépendants as a regular and less cliquish exhibition space for those involved in the new art. The Impressionist initiative made the break with the obligation or desire to exhibit exclusively, or indeed at all, at the official Salon. Such independence was, moreover, entirely in keeping with the cultural policies of the Third Republic, in which independent enterprise was encouraged by republican cultural managers.[11] The Republic's liberalism, namely *laissez-faire*, meant distaste for government inter-ference and the government applauded artists' attempts to make new circuits of exchange and distribution independent of the state.

These new strategies are not only typical of their political moment but also symptomatic of the economic modernization of artistic practice by capitalist forms of production which are based on private producers making commodities for exchange on a market. In the case of cultural practice, product identification and validation took place through the expansion of circulation and publicity systems. To become cultural capital and make cultural profit, the art work as product must be incorporated into a public discourse through recognition by a critical framework within which both the particular character of the product (the *difference* achieved by this gambit) can be named and its relation to an already valorized context of meanings can be identified (its *reference*).

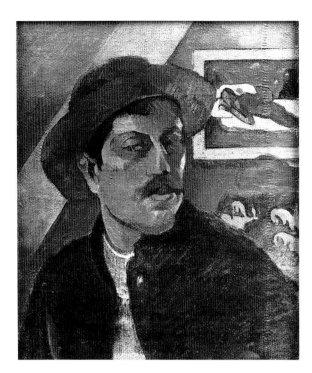

7 Painted in Paris, this self-portrait includes *Manao Tupapau* (1892), Gauguin's most significant and notorious painting from his first trip to Tahiti (1891–93). This is a mirror-image, therefore *Manao Tupapau* is reversed. Manet had similarly included *Olympia* (1863) in his portrait of his champion, *Emile Zola* (1869).

This complex process increasingly involved the manufacture of a public identity for the artist/producer which would stabilize and secure additional value for the product/art. The promotion of the self – the artist as author – was a specific effect of the processes of commodification which this stress on personality and individuality might seem to belie. The relations between the product and producer invert the typical ideological formation under capitalism – namely, the fetishism of the commodity – by creating an excessive mystique for, and overvaluation of, artistic personality. Gauguin was typical of this process, his oeuvre a specific narrative of it.

Women in Bed

8, 7 At the one-man show at Durand-Ruel's, Gauguin exhibited *Manao Tupapau*, the painting shown behind him in this self-portrait. The title, given in pidgin Tahitian, literally means 'Spirit; Thought'. We think it is trying to say: a woman lies alone in the dark and imagines the spirit of the dead watching her.[12]

16

The spectator in Durand-Ruel's gallery in Paris in 1893 was positioned in front of a very famous avant-garde bed, which has been transported from the Rue Bréda in Paris's red light district to the South Seas where it acquired some more colourful bed-linen. Now it is back in Paris. It is, of course, Olympia's bed. The painting of that title, executed by Manet in 1863 and exhibited at the Salon of 1865, had entered the public domain again in 1889 when it was shown at the most colonial of nineteenth-century world exhibitions, the Exposition Universelle in Paris. In 1890 Monet had raised a subscription to buy it for the nation and it was placed in the Luxembourg Museum, the national home for contemporary art (and not in the Louvre, as intended). In February 1891 Gauguin had made a copy of the painting, and the copy was in fact on show in Paris in the autumn of 1893 at the fifth exhibition of modern art at Le Barc de Boutteville Gallery. He also had a photograph of *Olympia* which he had taken with him to Tahiti.[13]

9

10

8 Gauguin, *Manao Tupapau*, 1892. Exhibited in Copenhagen in 1893 and then in Paris, this painting was Gauguin's big stake in avant-garde game-play in relation to what was then still the key subject of Western painting, the female nude.

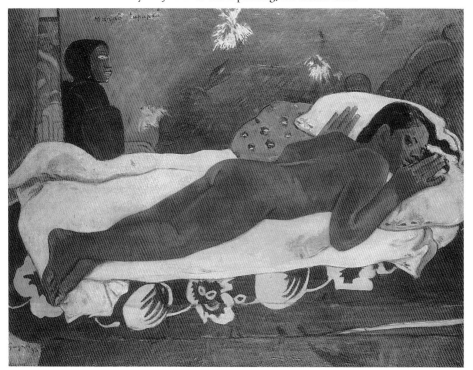

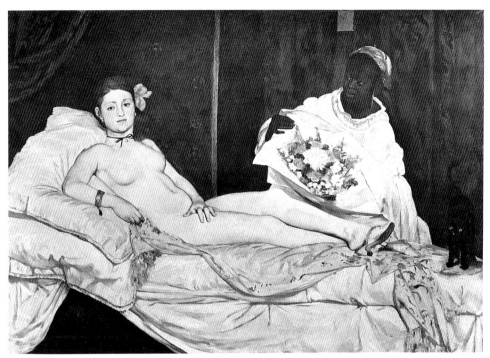

9 Manet, *Olympia*, 1863.

10 Gauguin, copy of Manet's *Olympia*, 1890–91.

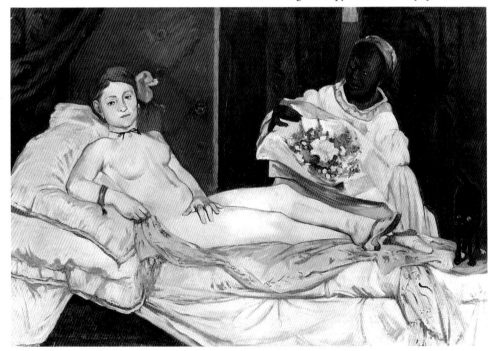

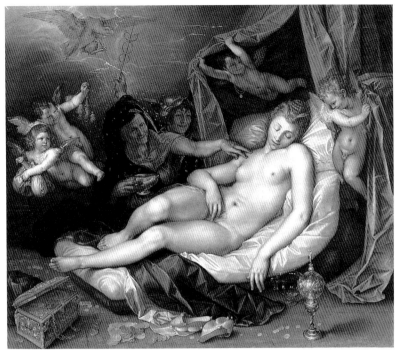

11 Goltzius, *The Sleeping Danae Being Prepared to Receive Jupiter*, 1603.

12 Titian, *Venus of Urbino*, 1538.

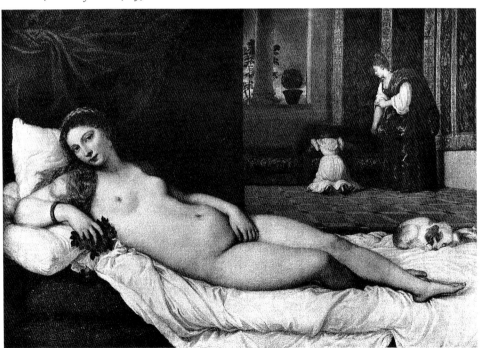

Manao Tupapau shows us a young Tahitian woman on a bed. Women are often in bed, according to Hélène Cixous, who writes:

In *La Jeune Née* I made use of a story to me particularly expressive of women's place: the story of Sleeping Beauty. Woman, if you look for her [in patriarchal culture] has a strong chance of being found in one position: in bed. In bed and asleep, 'laid (out)'. She is always to be found in or on a bed: Sleeping Beauty is lifted up by a man because, as we all know, women don't wake up by themselves; man has to intervene, you understand. She is lifted up by the man who will lay her in the next bed so that she may be confined to bed ever after, just as the fairy stories say. . . .[14]

Two famous images embody this myth in Western painting, those of
12, 11 Venus and of Danae. If the woman in the latter is in bed, she is often accompanied by another woman, who functions as the foil to her beauty, the crone to her youth, 'death' to her 'sex'. Despite the appearance of difference, both figures are faces of one male fantasy – woman, who is by turns desirable and deadly. As I lay the weft for the pattern this book will weave, I want to point out how often in Western pictorial tradition these two faces are distinguished by colour. The old crone's is both darker and harder than the soft pallor of the passively receptive, youthful Venus or Danae.

The reference to Manet's *Olympia*, unlike Manet's to Titian's *Venus of*
12 *Urbino*, was quite obvious to the public in 1893.[15] Gauguin's gambit is exemplary of the avant-garde strategies of reference, deference and difference which appear to stage a typically Oedipal formation: reference to the Father (that is, the artist who currently dominates the selected scene or group), deference to his coveted place, and difference, the deadly blow by which his place is appropriated or usurped.[16] Several contemporary critics in 1893 noted the connection between *Manao Tupapau* and *Olympia*. Writing in *La Revue blanche* in 1894, Thadée Natanson confirmed that *Manao Tupapau* was called the 'Olympia of Tahiti',[17] but Alfred Jarry, writing in the Livre d'Or at the Gloanec Inn in 1894, phrased the connection differently, signalling the critical difference between the two paintings and two moments of the avant-garde: the issue is colour.

20

Manao Tupapau
drowsy is the wall
and brown Olympia lies
on her couch of golden arabesques.[18]

At the compositional level, the similarities between *Olympia* and *Manao Tupapau* are indeed striking – the massive bed across the plane of the painting on which is spread a naked body served up on a sheet of dazzling white linen, set off by a patterned background. In both there are expressive hand gestures, and the composition is based on a contrast between a supine nude and a clothed but upright figure.

Dark Ladies

One major difference – and there are many others that will be discussed shortly – is what has happened to the standing figure in *Olympia*, so often overlooked by white art historians, who frequently write of Manet's painting as if it contained only one body, one woman. In Gauguin's painting, the maid figure is now the spirit of death. This change inscribes not only the sexual but also the racial politics of Gauguin's practice. The maid in Manet's painting, modelled by an Afro-Caribbean woman known as Laure, represents Olympia's companion in their domestic service industry. Her clothing – part Western, part African – is indicative of her cultural predicament. Her turban evokes her belonging to a specific geographical and cultural identity which, in Paris, would have read as the sign of the exotic other. It is a real example of African and Afro-Caribbean headgear; but it was also a generalized sign used in orientalist painting. The combination of a white woman attended by a black woman is a commonplace of that orientalism, which Manet's painting disrupts by its prosaic staging of the elements of the fantasy in his studio, placing the scene firmly in Paris. The painting's negation of orientalism emerges from its assertive modernity, a here and now-ness of the working woman hired to model as a courtesan attended by another working-class woman, displaced from her African home through colonial slavery and now in wage slavery. This fact of displacement is signified above all by the overlarge, ill-fitting European dress which

13, 14

21

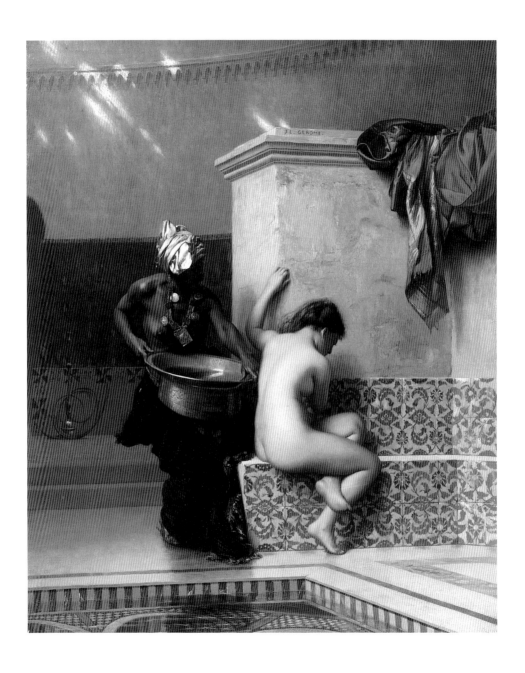

clothes a body which, in orientalist art, would have been both exposed and represented as the foil to the plump white woman's brilliant, and desired, flesh.

Gauguin has evacuated any residue of the social and historical specificity so carefully constructed by Manet for this African woman from the French colony of Martinique living in Paris in 1863 by turning her into a dark lady and then into a spectre, a spirit, a phantom of the prostrate woman's imagination. The shift is possible only through a signifying chain in Eurocentric discourse which slides from Blackness to Darkness and Death.[19] Gauguin named this figure the Spirit of the Dead. A decade before Picasso, he conflated his fantasies of sexuality and death with those cultural forms of the 'Tropics' he had confected from European anthropology books and international colonial exhibitions, forms which, in relation to his European sensibility, most vividly signified both racial and sexual difference. A colonial perception and projection of difference becomes the form of an aesthetic difference deployed against the European culture within which alone Gauguin could be 'Gauguin' – an artistic author, an aesthetic commodity.

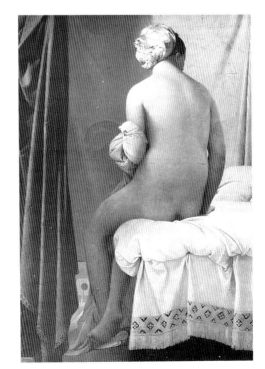

13,14 *Opposite* Gérôme, *The Moorish Bath*, 1870. *Right* Ingres, *The Bather of Valpinçon*, 1808. The nude was given new life by the orientalist movement, a Western myth about the Islamic world, which colonizing Europeans refashioned through literature and imagery as a timeless mise-en-scène for erotic fantasies of captive, sexually subservient women.

Gauguin's return to orientalism, disguised by its formal innovation, has, however, made both women two faces of a European image of the 'dark lady' which has, since the Renaissance, haunted the Western imaginary.[20] The image of the tropical journey, 'with its cargo of sexual adventure and questions of identity', informs many texts, especially from the nineteenth century to the present, from Rider Haggard to Kipling, Thomas Mann to Freud, from Baudelaire to Conrad and to Claude Lévi-Strauss, author of a most vivid exemplar of the genre, *Tristes Tropiques* (1955). In her study of the tropical journey as a myth system traced from Baudelaire to Lévi-Strauss, Cleo McNelly argues that the 'native woman' becomes the primary object of interest of the tropical guest, because she combines the 'otherness' of both race and sex. McNelly writes,

All these motifs, of course, depend upon a central polarity: the binary opposition between *here* and *there*, home and abroad. For Conrad (and for Baudelaire and Lévi-Strauss as well) home represents civilisation, but also order, constraint, sterility, pain and ennui, while native culture, the far pole of the myth, represents nature, chaos, fecundity, power and joy. The home culture is always associated with light, and the ability to understand by seeing, abstractly, while the other culture is associated with black, with the sense of touch, the ability to know by feeling, from within. The far pole of the tropical journey is indeed the *heart* of darkness.[21]

The tropical journey's poles are represented by two women, the white woman at home and the dark lady out there, nowhere so vividly dramatized as in Joseph Conrad's story 'Heart of Darkness' (1902). The black woman is 'the everpresent exogamous mate, the dark lady of the sonnets, savage, sexual and eternally other. At her best she is a "natural woman", sensuous, dignified and fruitful. At worst she is a witch, representing loss of self, loss of consciousness, loss of meaning.'[22] That is, she is Death, the 'spirit of the dead watching' – but watching whom? These mythic figures of light and dark, white and black, are creatures of a Western masculine imaginary. McNelly points out that almost every woman, white or black, has been cast in both of these roles, irrespective of her objective situation in terms of colour or race.[23]

24

Reading Gauguin's trip to Tahiti as part of this longer history and deeper structure of the 'tropical journey' allows us to grasp the nature of his misreading of Manet's *Olympia*. Manet's gambit as an anti-orientalist tactic is revoked by the double darkness by which it is reframed. The dark lady is figured now in both faces of that myth – the natural, sensuous, desired body (in place of the tainted, urban working-class prostitute) which is set against, yet identified with, the darker, deadlier crone or witch (who replaces Manet's remarkable historical portrait of an Afro-Caribbean woman at work within a commodity economy).[24]

Who Is Looking? What Is Shown?

But beyond these overt similarities and decisive differences, between *Manao Tupapau* and its avant-garde referent, *Olympia*, lies a structural correspondence. *Manao Tupapau* projects a space beyond the frame of the canvas which is the location of the implied and necessary third party. A viewer for the scene is invoked by the direction of the gaze of the woman on the bed and assumed by the narrative Gauguin has to invent. In the case of Manet's *Olympia* there was also an implied narrative. It was indelibly social. From Zola to T. J. Clark, writers have easily identified the prostitutional discourse in which the painted scenario was read in the 1860s, scandalously implicating the viewer at the Salon with the work space of a decidedly contemporary courtesan. For his painting Gauguin created a narrative context, both specific to his adventures in the South Seas and typical of the colonial context in which they took place. This is the story as it appears in the Louvre manuscript of the book published as *Noa Noa*.

One day I had to go to Papeete. I had promised to come back that same evening. On the way back, the carriage broke down half way: I had to do the rest on foot. It was one in the morning when I got home. Having at the moment very little oil in the house – my stock was due to be replenished – the lamp had gone out, and the room was darkness when I went in . . . Tehura [Teha'amana] lay motionless, naked, belly down on the bed: she stared up at me, her eyes wide with fear, and she seemed not to know who I was. For a moment I too felt a strange uncertainty. Tehura's dread was contagious; it seemed to me that a phosphorescent light poured from her staring eyes. I had

never seen her so lovely; above all I had never seen her beauty so moving. . .
Perhaps she took me, with my anguished face, for one of those legendary
demons or specters, the *tupapaus* that filled the sleepless nights of her people.[25]

We can imagine for a moment this scene, the young woman's
petrified state as she associates footsteps with the approach of the deadly
demon of the night. Gauguin's painting is only distantly related to this
probably fictionalized moment. Giving a form to the spirit, he creates a
surrogate spectator *in* the painting, which then contains and relocates the
young Tahitian's fear and misrecognition of him, the intruder. It
displaces his voyeurism onto her paranoia. The anthropological
narrative veils the desires aroused in him by the scene by insisting that
what he shows is merely a representation of her, Tahitian, superstition.
Then, by formal reference to Manet's *Olympia* – the avant-garde
treatment of the nude – Gauguin reintroduces himself, claiming a place
in that avant-garde in another, less vulnerable position, as artist, as
owner, as European man outside the painting.[26]

The scene the painting commemorates only exists under his gaze, the
illumination provided by some matches – he mentions that he struck
matches in the published version of this episode – reiterating the
opposition: dark/light, black/white, fear/knowledge. Without that
white gaze, moreover, the painting's projected meanings do not
function.

These meanings were very risky, then as now. Indeed, so dangerous
did his gambit appear that Gauguin was impelled to supply a framing
discourse to attempt to stabilize its contradictions and displace the
overtly racist implications. Gauguin wrote letters to his Danish wife
Mette, which I shall later cite, as well as preparing a notebook for his
adolescent daughter Aline about this work. In the notebook the need to
create an armature of supplementary meaning which would redirect
attention from the seemingly obvious leads to an appearance of disarming
honesty:

A young native woman lies flat on her face. Her terror-stricken features are only
partially visible. She rests on a bed which is draped with a blue *pareu* and a cloth

15 Susanna, a virtuous wife, was spied upon as she bathed by two lecherous elders, who threatened to denounce her as an adulteress — a capital crime in ancient Biblical times — if she did not submit to their advances. She resisted; they denounced her; they were executed for false witness. This version of the story, by 17th-century Bolognese artist Artemesia Gentileschi, represents the 'visual rape' in all its anguish, despite also offering Susanna's naked body frontally to the viewer.

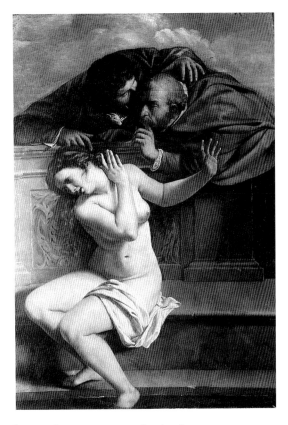

of chrome yellow . . . I am attracted by a form and a movement, and paint them, with no other intention than to do a nude. [Gauguin is already quoting and deferring — this is Zola's comment on Manet's *Olympia*.[27]] In this particular state the study is a little indecent. But I want to do a chaste picture, and above all render the native mentality and traditional character . . . What can a nude Kanaka girl be doing quite naked on her bed in a rather risky pose such as this? She can be preparing herself, of course, for lovemaking. This is an interpretation which answers well to her character, but is an indecent idea which I dislike. If on the other hand she is asleep, the inference is that she has had intercourse, which also suggests something indecent. The only conceivable mood is one of fear. But what sort of fear has possessed her? Certainly not the fear shown by Susannah when she was surprised by some old men. There is no such fear in the South Seas. No, it is, of course, the *tupapau*. The Kanakas are always afraid and leave a lamp lit at night . . . As soon as this idea of a *tupapau* has occurred to me, I concentrate on it and make it the theme of my picture. The nude thus becomes subordinate.[28]

15

This piece of uncertain honesty and self-justification and the letters to Mette Gauguin expose Gauguin's real anxiety about the work's public reception in Europe and its possible reflection on its producer. What is as interesting is the clarity with which the notebook exposes the structure of European masculine heterosexuality, its eroticism dependent on opposing pairs, such as the licit/illicit, the chaste/indecent, the sexual/ aggressive, the anthropological/voyeuristic. These binary oppositions appear to be absent or irrelevant to what Gauguin benightedly calls the 'native mentality'. Without the poles across which Western male sexuality functions (*Susanna and the Elders* is another implied referent), the image could pretend to be 'chaste'/licit/anthropological in its nudity. Yet because of the context in which it would be exhibited and read, the disguise of his identification with the 'native mentality' will be torn away, and the painting's inception within a Western sexuality will expose it along the dangerous axis of illicit/indecent/aggressive/ voyeuristic.[29]

1863, 1886 and 1893: The Play of Reference
I want now to explore further Gauguin's gambit of playing off formal reference to *Olympia* and deference to the authority of its author as a way to protect and make an entrée for his outlandish image in the Parisian avant-garde.

Despite the apparent differences, Parisian critics confidently estab-lished continuities between *Olympia* and *Manao Tupapau*, between Manet and Gauguin, between 1863 and 1893. Operating beneath the pluralized surfaces of Verhaeren's metaphor of the kaleidoscope and art history's market-led insistence on innovation and individualism is the deep structure of metropolitan avant-gardism. An avant-garde gambit works only if you can evoke a reference text, and rework it so that its status is overcome and its place occupied. If the work is too different, reference will be stymied; if it is too close, deference will overwhelm its separate identity and it will seem merely derivative or, worse, banal and hackneyed. The ground rules for the game were already in place by the 1880s even though, as the decade progressed, they were themselves in flux.

28

The avant-garde script established in the 1870s to 1880s addressed spaces for and modes of representation: the spectacle of the rituals of urban social pleasure, its social bodies and eroticized territories. The room for manoeuvre was increasingly limited to the game of stylistics – formal novelties culled from museum culture, the mausoleum culture celebrated in the Exposition Universelle of 1889 which brought together modernity's pairing of historicism and colonialism. By the mid-1880s, however, when Gauguin made his bid to become a professional painter in the avant-garde, the dominating figure was in fact not Manet, but Seurat.

As a result of its double appearance at the eighth and final exhibition of the Impressionist group in May 1886 and, in September of that same year, at the Salon des Indépendants, Georges Seurat's *Sunday Afternoon on the Island of La Grande Jatte* had decisively transformed the field of Impressionist representation of leisure and pleasure. It was a classic example of an avant-garde gambit, the founding move, perhaps. Evoking and negating, Seurat's painting not only differed critically from the sunfilled geniality and simulated spontaneity of Renoir's 1881 *Luncheon of the Boating Party* but made it seem fanciful, romanticized and hopelessly out of date. This was accomplished precisely by the self-advertising deployment of highly specific artistic procedures which can be called style, which is evident as much in the hieratic drawing of the stiff figures as in that orderly, pseudo-rational method of application which unifies the surface while enlivening it with the so-called pointillist dot. To call this style is not to invoke the unconscious infrastructure which formalist art historians call style. A better term would be stylization.

Seurat made himself the guy to beat. Those wishing to find their place in the loose confederation that he was now seen to dominate had to establish themselves within the antimonies of calculation and licence by dealing with what he had done to his 'fathers'. In this competitive sibling rivalry, work produced which was ignorant of Seurat's move would look it.[30] What did this mean in practice? It meant following him into spaces of the city that were more problematic than the Fournaise Restaurant at Chatou (the popular eating house on the Seine where

17

16

Renoir's painting was sited), into the mongrel and hybrid territories north and west of Paris's fortifications – Asnières, Courbevoie, Clichy, Saint-Ouen. Here, Seurat and his followers seemed to believe that the modern could still be grasped in the very incongruities of the areas being remade by speculative capital – an apartment building here, a factory there, the end of the tramlines here, the grand emptiness of that section known as the Zone. All the paintings and drawings produced here spoke a quite different language from their predecessors at Argenteuil and on the Boulevards: the compositions inscribe the distance of the artists from these sites, and this distance itself sanctions the stylizations and formalizations to which they subjected these varied locations, often utterly devoid of workers. In those vast empty foregrounds very little is on show except a lot of brushwork.[31]

19

18

Seurat's territories and his formal stylization were hard to manage. Even when artists began to seek out other, possibly more tractable, spaces for avant-garde representation, his agenda determined what they did. In Arles Van Gogh paints local equivalents to the Grande Jatte in the

16,17 *Below* Renoir, *The Luncheon of the Boating Party*, 1881.
Opposite Seurat, *Sunday Afternoon on the Island of La Grande Jatte*, 1884–86.

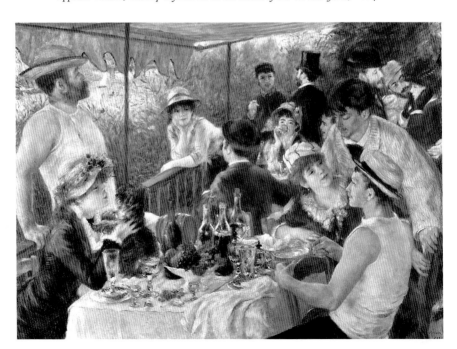

public gardens and Alyscamps, as well as the seedy cafes which 20, 21, 23
reminded him of the painting of tacky street entertainment he saw in 22
Seurat's studio the day he left Paris in February 1888.[32]

Gauguin's gambit after 1888 also involved a decisive geographical shift, from city to country, through which he effected a cultural translation of the avant-garde as well as the creation of a distinct facture, a style. This involved the most extensive appropriation to date of the treasury of non-Western art, Egypt, Java, Japan, whose cultures provided the syntax for an otherness, an unfamiliarity, a distance, which is too casually called the exotic in tourist literature and 'synthetist' in art historical literature. Gauguin probably hoped that a synthesis of exoticism would help him really achieve the necessary *difference* from those avant-garde leaders he had to refer to, in order to be recognized as a contender. Félix Fénéon, Seurat's anarchist apologist, acknowledged Gauguin's competition with Seurat for leadership of the new generation, but argued that Gauguin used the given, be it social or natural, merely as the pretext for what Fénéon insightfully named 'distanced creations'.[33]

Two contrasting images of the key themes of 'the new painting',
the commercialized territories of bourgeois and petit-bourgeois leisure:
the Renoir creating the myth, the Seurat demanding a critical distance.

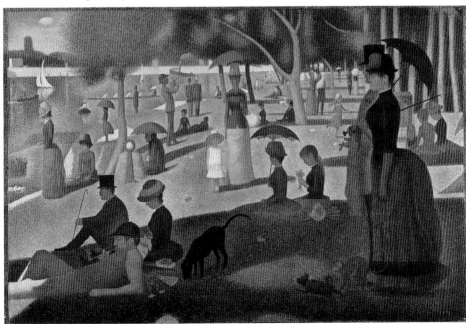

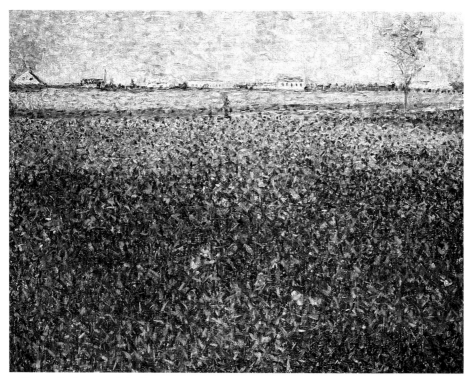

18 Seurat, *La Luzerne, Saint-Denis*, 1884–85.

19 Van Gogh, *View of an Industrial Town*, 1887.

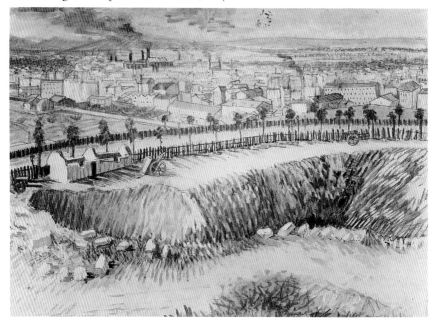

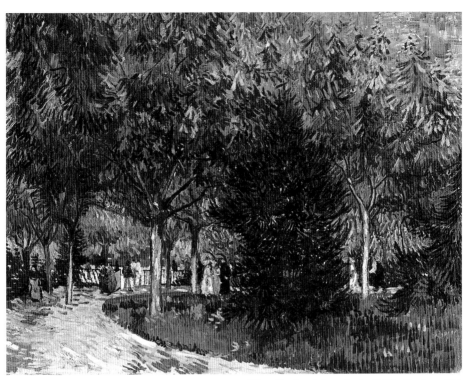

20 Van Gogh, *A Lane in the Public Garden*, 1888.

21 Van Gogh, *Les Alyscamps*, 1888.

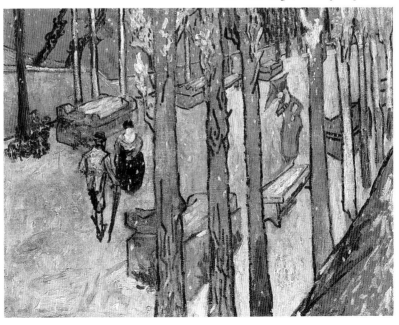

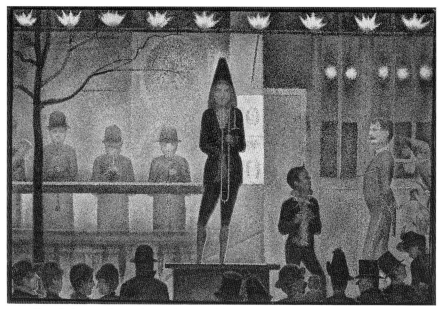

22,23 In paintings such as *The Parade*, 1888 (*above*), Seurat began to explore the arena of popular entertainment. Van Gogh also found such imagery in Arles, giving the scene *below* a Zolaesque melodrama by calling it after that author's novel of working-class drunkenness, *L'Assommoir* (The Night Café), 1888.

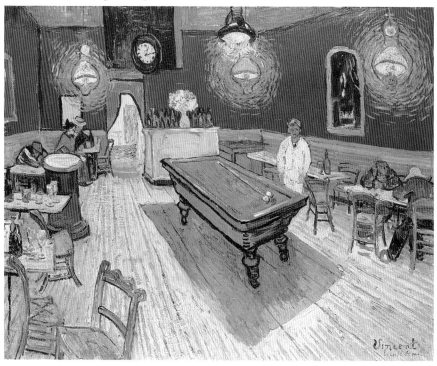

A distinctly jaundiced view of Gauguin's cultural pilfering appears in Pissarro's report on a visit to the Durand-Ruel exhibition of 1893 in a letter to his son Lucien dated 23 November of that year: 'Gauguin is certainly not without talent, but how difficult it is for him to find his own way! He is always poaching on someone's ground; now he is pillaging the savages of Oceania.'[34]

'Going Native', or The Politics of Prostitutionalization
Olympia was about European modernity figured by anxiety about commercialized sexualities in the modern metropolis. Could that modern sexuality 'go native', in Abigail Solomon-Godeau's phrase?[35] What did the transposition of anxiety about commercial and other sexualities signify when returned to Paris in 1893 in the representation, *Manao Tupapau*?

Olympia is a painting, a work by Manet, an avant-garde gambit for its moment in the 1860s. The painting's title is a name used in the higher echelons of the prostitutional trade, and it typically gets associated with the white female figure in the painting, rather than being read as referring to the social and symbolic situation collectively dramatized by both women. The black female figure remains nameless, an accessory to the sexuality of the working-class prostitute masquerading as a courtesan through her *nom de guerre*, 'Olympia'. Thus the name initiates a chain of meanings around economic and sexual exchanges in the interstitial places of cross-class sexual traffic characteristic of urban modernity.[36] *Olympia* is a representation of the spaces of bourgeois masculinity where working women's bodies are bought and sold, where money mediates even the most intimate bodily contacts. The painting signifies commodity, capital's penetration of bodies and desires, where the sale of monetary rights to the usage of a body, of a social and gender 'other', is also, for the bourgeois man, the purchase of pleasure and access to the experience of power.

In this game of *reference*, what happens to the Tahitian woman in *Manao Tupapau*? Does she become a prostitute? Is she maidservant and sexual commodity in one? There certainly was prostitution in Tahiti's capital and with it came sexually transmitted diseases. Prostitution is part

of what it means for non-European women to encounter European men, as Vietnamese and Thai women know to their cost today. What we know about the social relations from which this painting was produced does not, however, confirm such a suggestion.

The model's name is Teha'amana, which means bringer of strength. She was thirteen years old and Gauguin was married to her. He had gone on a journey into the island's interior to escape the tarnished modernity of the colonial capital Papeete, where women were openly on the market. Once in Fa'aone, on the East Coast of Great Tahiti, he encountered a family who asked him what he wanted. He said, 'Give me wimmen!' – or perhaps he phrased it, according to his own memoirs, 'I am searching for a wife.'[37] They produced their foster daughter and according to the local rites and customs they were married, an action sealed by Gauguin's gifts to both foster and actual sets of parents. By this exchange Gauguin gained what was necessary for him to function as an artist. In the absence of shops and restaurants, he needed someone to gather and prepare food. Given the threat of infection from the professionals, he needed a healthy and willing sexual partner. In the absence of an artistic culture and its proletariat – female models – he needed access to a naked woman in order to stake his claims via the time-honoured body of art, the nude. In Teha'amana he acquired a housekeeper, a sexual partner and a model an almost European arrangement which indicates how an artist's access to art's body, the nude, is economically conditioned, dependent on a proletariat of women, in whose absence in rural Tahiti Gauguin had to enter a most non-European arrangement – marriage to his model.[38]

Such a relationship, between a European man and a Tahitian woman, confirmed by local marriage customs and ceremonials, already had a place in Western thought through the writings of Pierre Loti – whose *Marriage de Loti* was published in 1880 – and would recur in Puccini's 1904 opera *Madama Butterfly*. All these stories reveal European cynicism. The white man gets a female body by dishonouring local customs, which he uses to enter local circuits of exchange of women without ever intending to regard them as binding. The possibility for such abuse involves both the gender power of men of *all* cultures to

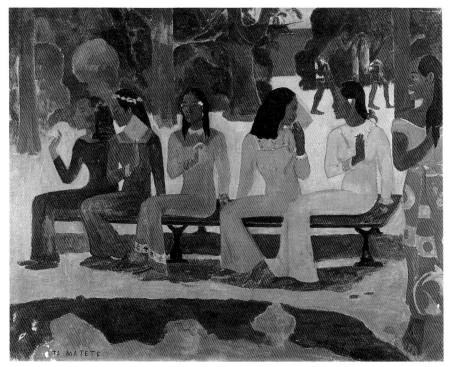

24 Gauguin, *Ta Matete*, 1892. Ta Matete refers to the market and the title is a pun on the women offering themselves for sale in the marketplace of Tahiti's colonial capital, Papeete. Note the irony of the fact that they are wearing the modesty dresses imposed by the missionaries.

exchange women and the racist structures which empowered *some* men to enter and dishonour the kinship system of other men whom they cast as racially and hence socially inferior.

In her own eyes, Teha'amana was not a prostitute. In terms of her socialization within a local form of patriarchy she was a young wife.[39] But from a European point of view, as this painting of her was appraised in its Parisian artistic setting, it was not possible to read this thirteen-year-old woman of colour as a 'wife'.

The term 'wife' does not refer only to a woman with a legal certificate of marriage. It is also symbolic of a position within a sexual exchange system, namely, the kinship structure of the Western bourgeoisie. 'Wife' designates a form of private property, a placement in regulated domestic

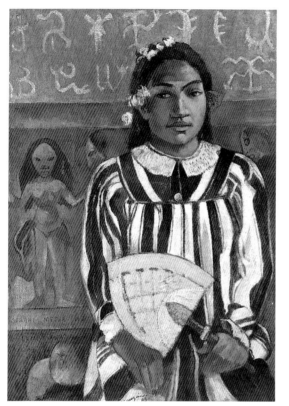

25,26 *Left* Gauguin, *Merahi metua no Teha'amana* (The Ancestors of Teha'amana), 1892. *Below* 'The daughters of Auguste Goupil wait in front of their father's villa in Punaauia for the arrival of their drawing master, Paul Gauguin'. Gauguin moved between two worlds, that of the islanders and that of the colonists. The latter retained their European dress and corseted 'femininities' in the Tropics. The contrast was maintained despite the shapeless sack inflicted on Tahitian women by the missionaries.

27 *Opposite* Shown at the Paris Salon in 1863 and inaugurating an attempted revival of the classical nude, Cabanel's painting *The Birth of Venus* is the direct contemporary of Manet's *Olympia*. It exemplifies the accepted forms of bourgeois representation of femininity and sexuality which Manet disrupted.

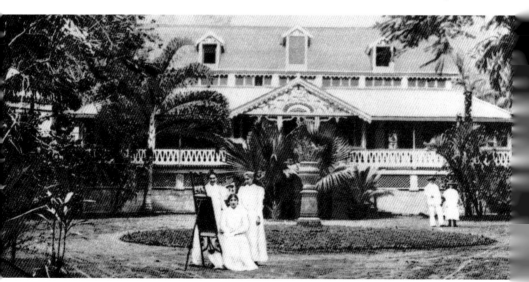

space, a legalized exploitation of a sexual body for reproduction. The antithesis within bourgeois ideology is the term 'prostitute', a symbol of that interface of sexual and capitalist exploitation of working women's bodies as providers of both cheap labour and sexual service. 'Woman' was the contradictory sign produced in the symbolic antimonies of 'wife' (synonym femininity): private producer of value for men; and 'prostitute' (synonym sexuality): debased, used but desired body of consumption.

Teha'amana's body would not read as 'wife' in European terms. Take her age. In many cultures puberty and the onset of menstruation mark the coming of adulthood, when fathers put their daughters on the market.[40] In late nineteenth-century Europe this custom was extinct. Adulthood was delayed and legally defined. Under the age of consent, an active female sexuality would more probably signify criminal behaviour or child prostitution.[41]

Nor is Teha'amana represented in the codes of femininity. These are integrally bound up with clothing: femininity as a masquerade, a veiling, a body literally re-*fashion*ed. She is negatively 'dressed' – undressed – in 25, 26
the opposing signs of sexuality. Socially, these imply the matter of class, which is managed in the codes and privileged spaces of art, through the rubric of the nude. Here a working woman hired to model for an artist is 27
refashioned – almost clothed – via a process of idealization/de-realization to offer an aesthetic form of sexuality which can be discussed in the displaced vocabulary of Beauty and lyricism.[42]

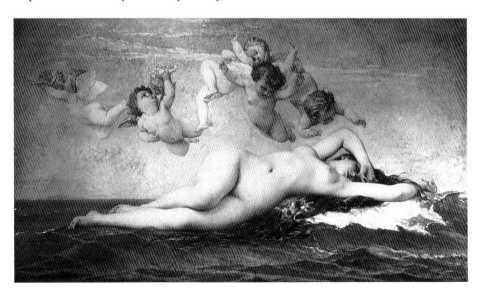

28 Titian, *Sacred and Profane Love*, *c.* 1575. Scholars disagree about the iconography of this painting, which may represent the opposition of the Celestial (nude) to the Earthly Venus, or of Venus to Chastity. Both pairings indicate the polarities of femininity and sexuality in Western culture.

Manet's painting, *Olympia*, however, had effected a dramatic shift in the traditional and contemporary discourse of the nude. Modernizing the typologies of sacred and profane love, as well as the association of nudity with truth, the painting made a virtue of insisting on the female body's social identity constructed by a modern, urban and classed organization of sexuality.[43] Gauguin's relocation of *Olympia* in Oceania erodes the cultural specificity of the Tahitian woman's body by returning it, as a differently coloured nude, to European art. In the same gesture, the Polynesian coloration of *Olympia* erases the latter's social meanings in this transposition of the bed and the woman to the colonies. The painting now functions mythically, precisely as a traveller's tale of the dark ladies encountered on a tropical journey. The painting *Manao Tupapau* seems to confirm the existence – elsewhere – of a pre-capitalist domain of nature. Its actual geographical origin was not an 'Edenic' Tropics but an island nation taken into the French colonial system which was being structurally reshaped and, as it were, modernized precisely through the presence of the colonist. Under the colonist's gaze, Tahiti's cultural and historical specificity was frozen. It became the mise-en-scène for a fantasy, so that it can only signify difference – temporal, sexual, cultural, racial.[44]

Manao Tupapau is placed, therefore, on a contradictory axis. The painting *references* the modernity of *Olympia* only to erase it with a racist fiction about the fascinating and desirable *difference* of a pre-modern

40

world of simple, superstitious Tahitian women afraid of the spirits of the dead. This totally fantastic scene signals an urgent search for escape from the insistent modernity of Manet's *Olympia* and the urban sex-cash nexus it had critically articulated in the privileged space of European art, the Salon nude. The Tahitian woman on Olympia's bed is in fact *Olympia*'s very antithesis. She signifies the opposite of that corrupted, venal, tainted metropolitan woman of the streets whose body is the conduit for sexual 29 discharge and the flow of money. The Tahitian country girl has her sisters not in Paris but in the imaginary countrysides of rural Europe where the bodies of European peasant women were painted to signify the promise of sex freely given as part of nature's bounty.[45] Nonetheless, the 30

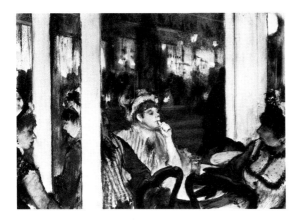

29,30 *Left* Degas, *Women in front of the Café, Evening*, 1877. *Below* Breton, *Calling the Gleaners Home*, 1859. These paintings – one avant-garde and one Salon naturalist – provide the contrasting images of debased and venal working women of the city and graceful and pure women of the countryside.

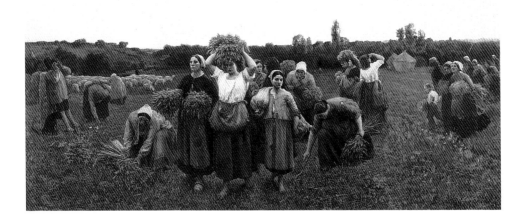

image of Teha'amana cannot but be assimilated to the prostitute because the painting belongs to a colonial discourse and functions as a text only in Paris, which was both the capital of the avant-garde and of France's colonial empire. In Paris, the painting was read according to its local ideological – aesthetic and colonial – frameworks.

In that space – Paris – assumptions shared by men in the avant-garde subculture were determined in the larger social formations of class, gender and race characteristic of France at that moment. But there were explicit concerns which identified the particularity of avant-garde culture. These focused on the means of representation, issues of style, form and colour. This was the language of stylistics, of gambits, Japanese art, synthetism, symbolism, exotica . . .

Alfred Jarry's telling phrase, '*brown* Olympia', is a condensation by which the implicit – racism – is expressed by the explicit discourse of art – colour. To call Teha'amana brown is to use an aesthetic vocabulary whose effect is to erase the geographical, cultural, social and personal specificity of this woman and to collaborate with how she is re-/disfigured through Gauguin's stylistic gambit.[46]

The Fetishism of Colour, or *The Psychoanalysis of Racism*
Within the discourse of racism, colour – the amount of melanin in the skin – functions as a fetish. In his telling analysis of the predicament of the colonized subject, *Black Skins, White Masks* (1952), Franz Fanon recounts his traumatic encounter with a white child whose fearful labelling of him as other, a Negro, left him, in his own brilliant words, 'spattered . . . with black blood . . . My body was given back to me sprawled out, distorted, recolored, clad in mourning on that white winter day.'[47]

Fanon used the terms of psychiatry to characterize 'the extremity of [the] colonial alienation of the person', the structural depersonalization of the colonized subject.[48] Colonial domination is not only economic and political. It is psychological as well, forming an ambivalent field of relationships and identifications which implicate both colonizer and colonized in distorted figurations of desire in which the personality and the body of one group is literally colonized by the desires and meanings of

42

the dominating group, turning Arab and African peoples into projections for Westerners of the 'Otherness of the Self':

The representative figure of such a perversion, I want to suggest, is the image of the post-Enlightenment man tethered to, *not* confronted by, his dark reflection, the shadow of the colonized man, that splits his presence, distorts his outline, breaches his boundaries . . . This ambivalent identification of the racist world – moving on two planes without being in the least embarrassed by it, as Sartre says of the anti-Semitic consciousness – turns on ideas of Man *as* his alienated image, not Self and Other, but the 'Otherness' of the Self inscribed in the perverse palimpsest of colonial identity. And it is that bizarre figure of desire . . . that compels Fanon to put the psychoanalytic question of desire of the subject, to the historic condition of colonial man [*sic*].[49]

Like Fanon himself, I think psychoanalysis can illuminate the construction of both sexual and racial difference, locating the drama that is constantly replayed in terms of a Freudian narrative of how all subjectivity is formed. According to psychoanalysis, subjectivity, the possibility of enunciating oneself, an ego, a self, an 'I', is produced through a series of splittings and stagings, initiated around the processes of identification with the Other/others. Through the allegory of the mirror phase, the French Freudian Jacques Lacan argued that the possibility of becoming a subject is the result of an encounter with an image, which therefore offers us a way to 'imagine' being a person – but from outside. The mirror is not-us, and hence signifies as the space belonging to the Other (Parents, Society, Culture). As still relatively helpless infants (6–18 months) we identify with this mirror image of a seemingly whole and competent body. We are captured by it. We are, however, also threatened aggressively by the fact that it is Other, which registers the fact of difference and separation. To be a self, we must acknowledge this difference. But difference – based on separation – is threatening because it replaces feelings of continuity and unity. The threat can be overcome by identifying with the image (based on the assumption that even if it is separate, it is like us), or by aggression towards that which precipitates this sense of division and incompleteness – othering some part of what also constitutes us as a self.

Sexual difference in the subject, the positions of masculinity and femininity, are also produced across this paradox of identification and disavowal of difference. In the mirror, there is the opposition of the child, as yet not a self, and the Other/Parent, in relation to whom the child is forced to acknowledge separation at the point at which its capture by its own image provides the possibility of a self. In this binary opposition separation can be negotiated through identification, not only with the image itself, but with the other figure who is party to the mirror phase, the Parent/Mother/Other, holding the child up to look and thus confirming what it sees. Sexual difference – acknowledgment of gender – is precipitated when the child is confronted with difference in the form of two terms – not just Image/(m)other but self versus two parents defined as different from each other. This produces a triangle whose unequal points are child choosing between sexually differentiated parents: Father and Mother. The sexually differentiated parents signified by the terms 'mother' and 'father' are the embodiments of social codings and cultural systems, not biological sex. They are terms of value, and hierarchy. The child must select one of two possible identifications and these choices are directed in accordance with a series of names through which the child of each sex is encouraged to recognize itself, names such as boy/girl, son/daughter, future father/mother, future husband/wife. These encode social values in which the former sets are hierarchically more endowed than the latter. Any choice – one must be made – involves a profound loss, and the recognition of lack. It is this symbolic loss or lack which Freud figuratively named 'castration'. Fetishism is a direct result of the fact that this drama of subjectivity is associated with sexual difference and therefore imagined in relation to one's own and parental bodies. Anatomy is not so much destiny as the signs of a psychic process. Fetishism is not a rare perversion, but, according to Freud, a widespread psychic defence mechanism created through the problematic of sexual difference.[50]

In order to have sex, the child must accept what amounts to annihilation, what Lacan movingly called the fading of its being before the signifier, namely, Language itself. I – the word I use to signify myself as a 'self' – is exactly where I – my being as a 'self' – is not. 'I' is a

linguistic term which promiscuously makes itself available to anyone. Language separates us – or, in specialist terms, alienates us – from a state of being-at-one with, or even able to feel identified with, the Mother, the parent associated with the beginnings of life, and its sustenance. Fetishism – as a defence against this discovery of difference and separateness – takes as its materials parts of the body which signify this drama of difference, fixating on what appears to be an indelible, physical mark of what is in fact a symbolic difference between the Father and the Mother. Fetishism is a mechanism for disavowing knowledge of difference from the Mother, while setting up what Freud calls a permanent memorial to the trauma its discovery occasioned. Fetishism can be understood as a way of thinking in which incompatible ideas can be sustained: I know she is different but I can go on believing that she is not really – that she does not signify the fact, and hence the threat, of difference which signals the extraordinary but inevitable condition of human subjectivity, a subjectivity predicated on its own alienation in language and its cultural systems.

It is only through the socio-cultural system that woman (mother) comes to signify difference as *lack*. Therefore what she appears to lack as part of her body – the phallus – comes to provide the material for the fetish, which tries to negate the predicament of desiring unity with an Other, when unity with that Other would annihilate one's own identity. Freud's narrative is, however, specifically relevant only to masculine subjects, who derive their identity from negotiating this difference from the Mother, which introduces the possibility of lack in the one who should not be so. In psychoanalytical terms, masculinity is, therefore, to be understood as a subject-effect which is based on fear of physical dismemberment, itself a metaphor for a psychological condition – a lack-in-being. So intolerable is the fear of this psychic lack, that it is projected out and onto the image of woman as lacking, in distinction from which the masculine subject sustains himself as man, a site of imagined wholeness.

Translate this into terms of cultural difference. Instead of genital diversity being colonized to provide the terms of this defence against difference, skin colour is fetishized. It becomes the sign of a lack-of-being, which means a lack of power, a lesser humanity which is

projected out onto an Other. But behind the screen set up by the fetish is what the fetishizing process defends the subject against – the desire to escape the law of lack and return to an *un*differentiated world, an Eden of infantile sensuality, the unified, identificatory space of maternal plenitude. The fetish thus turns on a profound ambivalence.

The colonial stereotype in which Tahitian history and culture was fixed by visiting Europeans exhibits all the symptoms of this ambivalent but escapist fantasy of a sexually permissive, naturally fertile world of sights, sensations and free pleasures. What else does the story of Eden mythologize but a patriarchal reworking of a desire for a world without knowledge of sexual or other difference?

The text on racial difference runs like this. In the social, political or economically grounded confrontation with culturally different societies, the would-be colonizer experiences the encounter psychologically, using the body as a metaphor for much more complex forms of social, historical or cultural difference. Thus, finding that all people are not of the same skin colour – which makes the European relative, partial, in relation to what is in fact cultural and not racial difference – the white colonial subject makes a fetish of some aspect of cultural difference. The other is fixed by a stereotype of negative difference which is punitive and yet reveals its underside of desire to be like this other, a desired belief that all people are the same, that we can regain an untroubled, primal, 'Edenic' world. But the ambivalence is played out on a real historical stage, where fantasy, grounded in concrete political and economic power, enacts an 'epistemic violence' on the beings, bodies and subjectivities of the colonized peoples. Thus Fanon wrote,

'Mama, see the Negro! I'm frightened.' Frightened! Frightened! Now they were beginning to be afraid of me. I made up my mind to laugh myself to tears, but laughter had become impossible. I could no longer laugh, because I already knew that there were legends, stories, history, and above all *historicity*, which I had learned from Jasper. Then assailed at various points, the corporeal schema crumbled, its place taken by a racial epidermal schema . . .[51]

The racist version of fetishism makes the skin/colour a signifier for a culture so that it becomes an ineradicable, physical sign of negative difference. In the negating mirror of racist perceptions, Fanon does not

46

perceive a body-image with which to identify – to become a self – but an aggressive and alienating imposition of skin-colour as the only image of self permitted to him. That 'racial epidermal schema', his colour, refracts all the racist myths of his culture and people.

I was responsible at the same time for my body, for my race, for my ancestors. I subjected myself to an objective examination, I discovered my blackness, my ethnic characteristics; and I was battered down by tom-toms, cannibalism, intellectual deficiency, fetichism (*sic*), racial defects, slave-ships . . . On that day, completely dislocated, unable to be abroad with the other, the white man, who unmercifully imprisoned me, I took myself far off from my own presence, and made myself an object. What else would it be for me but an amputation, an excision, a haemorrhage that spattered my whole body with black blood?[52]

In Gauguin's work as it circulated in Paris, the body of Teha'amana is a fetish doubly configured through the overlapping psychic structures of sexual and racial difference. In art, as the nude, the female body is refashioned fetishistically, in order to signify the psychic lack within bourgeois masculinity which is projected out onto the image of 'woman'. The culturally feminized and racially othered body also carries the projected burden of the cultural lack – the *ennui* – experienced by some of the Western bourgeoisie in the face of capitalism's modernity. Gauguin talks so often of escaping the urban industrial West for renewal in the Tropics.[53] This is projected away from its source in Europe onto the body of a racialized other, who is then represented in terms which oscillate between love and hatred, envy and disdain, fascination and aggression. Teha'amana is presented as simple and childlike, yet savage and bestial; primitive but exotic; natural, generous and sensuous, yet promiscuous and deceitful. Around Tahiti, symbolized in Gauguin's paintings mostly as 'woman', thrive fantasies of 'Edenic' maternal plenitude which are fissured by other, equally compelling necessities to master, to keep a distance, to assert a difference, to remain European. A warm, naked, childlike body, offered freely, according to local patriarchal customs, was taken, recoded, debased, and aesthetically reworked, rendered distant and different, through its colour, the synonym of an infantile superstition against which the European man can maintain his fictional superiority: rational, in control, creative.[54]

Fetishism is a product of the discovery of difference, whatever it may be, which threatens the masculine subject sufficiently to initiate a process of disavowal of both its and the other's specificity. One insignificant detail of human diversity, be it anatomy or the amount of melanin, is used to turn heterogeneity into a dangerous game of difference. The other who elicits this confrontation with diversity is – according to a racist and phallocentric script – mastered by being negatively connoted as lacking, *yet also* marked by the excess of difference. Femininity is, for instance, just such a masquerade of absolute difference from men which is evaluated negatively. In the eyes of the threatened European, symbolic blackness, signified corporeally through skin colour, saturates the non-white peoples, signifying their excess of difference, in which shared humanity is suspended by the fetishization of colour.

Teha'amana's body is not represented in its social and historical or cultural particularity. It does not signify as the corporeal schema, the body image in which her historical subjectivity was housed and realized through its actions, its physicality as much as its emotions and intelligence. Why would she be lying naked thus if she were alone at night and afraid? Gauguin has converted her to the European fetish of the nude, an artistic management of masculine ambivalence about sexual difference. The critics complete the assimilation back to *Olympia*, marking a difference in the European canon of the nude by association with an avant-garde intervention in it. Thus Teha'amana's presence is erased as this painted brown body becomes a sign not of a particular Oceanic woman, but of European man, a sign of art, itself a fetishistic structure which defends us against the complexities of what Marx called real relations. Behind the label 'Olympia', by the imposition of that conversation between two avant-garde moments, Gauguin achieved his own precarious inscription into the avant-garde's narrative and canon. All these compound the excision from history of Teha'amana and whatever she might signify. What remains is the avant-garde fetishization of its own processes and procedures; not a sign of cultural specificity but merely the mark of difference from 'the privileged male of the white race', to use Gayatri Spivak's comprehensive term.[55] But if the historical spaces and social relations by which Teha'amana was

48

produced as a social and cultural subject are emptied by this avant-garde gambit, they were, nonetheless, the condition of its possibility.

Therefore we shall have to retrace the search for spaces of representation which characterized the fragmenting kaleidoscopic avant-garde community within which Gauguin was manoeuvring before he went to Tahiti in 1891. For Gauguin had already done much the same thing nearer to home, in Brittany in 1888, where class and merely regional difference provided the conditions for this fetishistic dialectic of desire and difference.

FRANCE 1888

The Purer Nature of the Countryside

During 1888, Gauguin, Bernard and Van Gogh all left Paris. It was a curious move to make at that time, given the avant-garde's strong identification with urban and suburban locations. They placed themselves at a geographical distance from the metropolitan avant-garde culture. But ideologically they remained part of it and identified by it.[56] This dialectic of distance and identification has to be grasped as the founding condition of what avant-gardists do. Distance was to become a key signifier at more than a literal level, as a critical reading of a letter written by Van Gogh to his brother Theo on 19 June 1889 from the asylum at Saint-Rémy suggests.

Finally I have a landscape with olive trees and also a new study of a starry sky. 31
Though I have not seen either Gauguin's or Bernard's last canvases, I am pretty
well convinced that these two studies I've spoken of are parallel in feeling.
When you have looked at these two studies for some time, and that of the ivy as
well, it will perhaps give you some idea . . . of the things that Gauguin and
Bernard and I sometimes used to talk about, and which we've thought about a
good deal; it is not a return to the romantic or to religious ideas, no. Nevertheless
by going the way of Delacroix, more than is apparent, by colour and a more
spontaneous drawing than delusive precision or *trompe l'oeil*, one could express
the purer nature of the countryside compared with the suburbs and cabarets of Paris
. . . Whether it exists or not is something we may leave aside, but we do believe
that nature extends beyond St Ouen.[57]

This letter articulates the theme of distance – of journeying away from Paris as both a topic and the resource for painting, of travelling via art history (Delacroix) away from Neo-Impressionist rigour and rationalism and the mongrel towns of northern Paris to the imaginary space, the purer nature of the countryside. Whether the purer nature of the countryside exists or not is immaterial.

This text sets the debased city, with its industrial suburbs and cabarets – equivalents to which Van Gogh had tried to find in Arles when he first arrived – against the countryside.[58] By 1889 Van Gogh wrote of a purer countryside, but it may no longer be concrete, actual. It is fashioned in art, and this radical shift is signified by the slippage from 'campagne', a socio-geographical location, to the ideological abstraction, 'nature'. The opposition is not industrial suburbs against rural Provence (or Brittany) but Paris (Modernity/Time/History) versus its total *ideological* antithesis, Nature.

In this letter Van Gogh is also distancing himself from a project which had preoccupied him and his two colleagues, which he characterized as a return to romanticism and religious ideas. The painting which is offered as the proof of altered concerns is *The Starry Night* (1889), an awkward confection of the local features of the Provençal countryside incidentally visible out of his hospital window and memories of Dutch villages and a Brabant church steeple remembered from childhood. If this is in any sense the purer nature of the countryside, it indicates that Nature has to be fabricated by untying the unities of time and space to produce a possible, but not an actual, landscape whose identity exists only as fiction, in the painting, through the surrogacy of art.

As a new gambit the painting was meant to refer, defer and then assert its winning difference in relation to the common concerns formulated by Gauguin, Van Gogh and Bernard as a particular fraction of the Parisian avant-garde. It was a total failure. Why?

This letter to Theo was written six months after Gauguin precipitately left Arles following one of Van Gogh's more severe epileptic seizures. There had been some correspondence but none to parallel the epistolary connection which sustained Van Gogh's contact

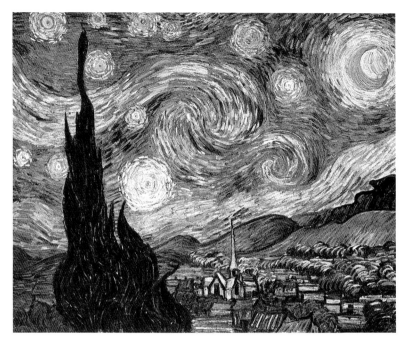

31,32 Van Gogh, *The Starry Night* (*above*) and *Mountainous Landscape behind St Paul's Hospital* (*below*), both 1889. A possible but not an actual landscape, *The Starry Night* combines elements of Provence and memories of Holland in a bid to propose such imaginary landscapes as a modern form of religious art.

with Bernard and Gauguin throughout the summer of 1888, or the immediate conversation with Gauguin during his months in Arles between October and December 1888.

Throughout the summer of 1888 Van Gogh's letters to Bernard outlined his programme for modern art. Paradoxically, it involved distance from the immediate world of social modernity. Van Gogh drew upon the project by some French critics to rehabilitate seventeenth-century Dutch art, which they defined as the product of a Northern, republican and Protestant society, and proposed as such as a model for a modern, naturalist art based on the portrait (of the middle classes) and landscape. The possibilities offered by the politically diverse historicism of Théophile Thoré, Charles Blanc and Eugène Fromentin to Van Gogh was the means to be modern while in fact defaulting on modernity. Van Gogh's programme to make a modern historical art based in the social processes of modernization in either city or country was a failure and he went to Paris in 1886 desperate to discover some way of proceeding, only to find that Paris offered no certainties, just the kaleidoscope of competing confusion. Removed from Paris, in a landscape he mis-recognized as Konincks and Ruysdaels, Van Gogh rifled his *musée imaginaire* and the baggage of critical writings on seventeenth-century Dutch art to produce a programme for what he called 'la peinture consolante', painting as consolation in face of the intractable complexities of social modernity. Not in fact a religious art, in terms of iconography, symbolism and narrative, painting as consolation will however perform the task hitherto associated with overtly religious art. That is, to offer comfort by proposing a permanent world of eternal value somewhere else, both distant and different from the transitory and indecipherable complexity of temporal societies. In this sense religious art is fundamentally anti-modern, the antithesis of modernity, which is precisely about historical time and social change.[59]

The interest in this sublimated form of religious art, therefore, articulates the paradox of a modernist project which is anti-modernity. Modernism is one of the symptoms of modernity. Culturally, it registered the erosion of meaning brought about by rapid social change. It represents a radical doubt about how to make sense of a social world

being remade by capitalism and its predominant forms, the cities of production and consumption. Modernism was forged in the gap which opened up between meaning (confidence that meaning was possible and consensual) and the means of representing a world changing and becoming so full of conflict that the possibility of shared or fixed meanings seemed constantly to evaporate. Religious art, as Van Gogh and critics such as Blanc understood the project, was an attempt to reinvent, on the other side of the radical secularization effected by urban capitalist societies, a coherent or permanent structure of meaning, a transcendent metaphysic which can promise if not deliver a guarantee on truth against the existential uncertainties and social ambivalence of modernity. The rash of reactionary cultural formations in the 1890s – symbolism, idealism, Catholic revivalism, primitivism and so forth – whether explicitly religious or obliquely so, drawing on German idealist philosophy, are indicators of a radical betrayal of the realist projects of the 1850s to 1880s. The latter had tried to forge new means of representation adequate to an engagement with the social spaces and relations of modernity. Pissarro, like Fénéon and others involved in the politics of anarchism, saw the choices in the early 1890s in stark terms, when the perennial crises of capitalism again put social relations under severe stress and necessitated clearly partisan choices as to whose side you were on.

Faced with the fact that to understand capitalism demanded espousing what Pissarro called social anti-authoritarianism and anti-mystical synthesis, many bourgeois artists succumbed to pure ideological reaction by seeking out a referent or reference point for art other than that of a *social* modernity. The debate about religious painting was precisely about the invention of just such another referent. This was to be art itself. The painting of consolation becomes art as consolation, a surrogate fictive world, and the avant-garde defines itself thereafter through its almost religious preoccupations with art's own procedures and process. Gambits and styles. Fetishism in its original and religious sense, perhaps.

Gardens of Gethsemane, Meadows of Meaning, Sermons and Visions
In 1888 Van Gogh, Gauguin and Bernard had competed with each other and with Paris, producing three significant paintings. Van Gogh's

33 Bernard, *Women in a Meadow*, 1888.

does not survive. He scratched it out several times. It was a painting of Christ in the Garden of Olives painted in Delacroix blues and yellows under a Rembrandtian starlit sky set in a Corot-like landscape. It was probably too frankly derivative and too far out of the stream of things. In the meantime Van Gogh learnt what his colleagues had been up to in Pont Aven when he received in a letter from Gauguin a sketch of the painting we know as *Vision after the Sermon*, with accompanying commentary. Gauguin called it 'un tableau réligieux'. In no sense a religious painting, the work's definition as such indicates more about Gauguin's ambition to score over Bernard, whose *Women in a Meadow* predates and precipitated Gauguin's painting. Perhaps writing about religious paintings in a letter to Van Gogh indicates Gauguin's knowledge of the correspondence with Bernard and a desire to ingratiate himself indirectly through Van Gogh with his dealer brother.[60]

Gauguin's *Vision after the Sermon* both contains and destroys narrative space by positing within one image two orders of space, two levels of

54

An intense moment of competition produced two different solutions (*bottom and opposite*) to the legacy of Seurat's *Grande Jatte* transposed to Brittany. Gauguin's sketch in his letter to Van Gogh does not include the priest (*bottom, far right*) to whom he gave his own distinctive profile.

34 Gauguin, Sketch of *Vision after the Sermon* in a letter to Van Gogh, 1888.

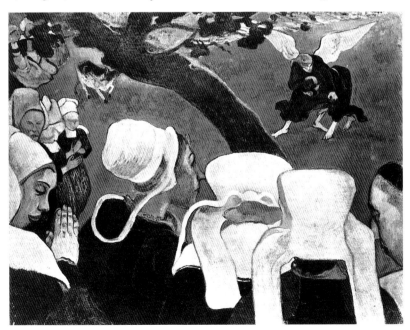

35 Gauguin, *Vision after the Sermon* (Jacob Wrestling with the Angel), 1888.

reality and imagination. We see Breton women emerging from a church, heads filled with the sermon they have just heard, images of which are projected out onto a blood-red field with Hokusai-inspired Japanese wrestlers who do service for the Jewish patriarch Jacob struggling with the angel, a scene from Genesis 32:22–32.[61] It is unprecedented to demand that a painting manage to function as both an image of a possible gathering of women from a specific French region and the projection of their overheated religious experience. I suggest that it can only work through the position of the spectator, proposed as a metropolitan and probably masculine viewer, positioned in utter difference from the peasant women, who are made 'exotic' by their costuming and are further de-realized through Gauguin's stylistic gambits which medievalize and orientalize their faces. Art historians typically quote Gauguin's letters about his fascination with Breton women for their rustic and superstitious piety – uncritically accepting the equivocation at the heart of Gauguin's project. It is a *tableau réligieux* only because of the hidden assumption on the presumed viewer's part of the religiosity of priest-ridden, gullible peasants, that is, simple-minded women who belong thereby to a bygone age. Gauguin's painting specifically opposes what Bernard's had done. Bernard had mixed

36 *Opposite* Gauguin, *Women in the Public Garden*, 1888. One of Gauguin's so-called abstractions (images created out of his imagination), this scene of women in Arlésienne costume refers to both Seurat and Bernard.

37 *Right* Gauguin, *The Yellow Christ*, 1889. Bold colour cannot disguise the desperate uses – the 'pilfering' – of the 'otherness' of Breton Sunday costumes and local sculptural forms to create a novel stylistic gambit out of regional religiosity.

'modern' Breton costumes with new urban fashions, locating both in the modern field of representation. Gauguin evacuates the modernity of Brittany by casting the scene into a pre- or non-modern field, of religiosity, superstition, visions.

It was not, as is often claimed, a new beginning for Gauguin. In Arles he was still vying with Bernard and Seurat, Pissarro and Cézanne as he haunted the Alyscamps, cafés and riverbanks. It was not until 1889 that 36 he returned to Breton religiosity and then by the crude means of including their calvaries in his pleasantly colourful landscapes. But he 37 did finally try out what Van Gogh had not risked in 1888, a *Christ in the* 39 *Garden of Gethsemane*, a sketch of which he sent to Van Gogh in a letter of 38 around 8 November 1889, just when Van Gogh also received photographs of Bernard's out and out Catholic, Italianate religious 40 paintings. Van Gogh was not comforted by this 'return to religious ideas and romanticism' and I suggest that *The Starry Night* was his reply. It 31

Van Gogh, a Dutch Protestant deeply influenced by Théophile Thoré's rabid anti-italianate and anti-Catholic polemic, was not prepared for his friends' literal 'return to religious ideas'. Wholesale revival of religious iconographies also allowed Gauguin to continue the cynical propagation of his own image, borrowing assorted costumes to fashion the myth of the tormented, misunderstood modern artist.

38 *Left* Letter from Gauguin to Van Gogh, 8 November 1889.

39 *Below* Gauguin, *Christ in the Garden of Gethsemane*, 1889.

40 *Opposite* Bernard, *The Annunciation*, 1889.

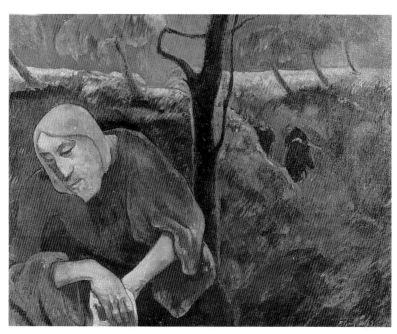

was sent to Paris as an antidote to Catholic, religious iconographies, offering instead a simple, rural church illuminated by a sky derived in part from one of Rembrandt's *Annunciations* which was meant to key his public into Carlyle's description of the city of heaven. No one noticed the gambit. Theo dismissed it as a 'village in moonlight' and the indifference generated a series of bitter letters from Van Gogh in which he ardently advocated portraits and landscapes as both modern and consoling as they would suggest *sensations possibles modernes* – the subjective condition of a reactionary modern man, whose emotions or sensations were the only residual link with the possible and the real.[62] With Van Gogh's final resolution of art as subjectivity expressed through agitated paint, he parted company from Bernard and also from the still ambitious Gauguin, who would pursue Van Gogh's notion of a distanced, specifically tropical Nature in a way that fulfils and ultimately reveals the deep structure within which this avant-garde game of gambits was being played out.

The matrix through which to grasp this contradictory anti-modern modernism, which emerged in the later 1880s, with art as the means to a surrogate world, is, I suggest, Tourism.

What else were Gauguin, Bernard and Van Gogh respectively in Brittany and Provence but tourists? What else is it but tourism that takes us to the place of the 'other' and subjects it to our 'othering' gaze, where we are geographically distant from home, but also ideologically distanced from the 'other' despite actual proximity. Tourism is, of course, an extension of the very economic and ideological process of metropolitanization. It is, as Dean MacCannell has argued, a decisive instance of that complex we call modernity.[63]

The metropolitan tourist from the civilized urban First World finds a place in the structures which First-World economies and ideologies colonize. There his/her gaze at the spectacle of nature and rural labour is protected and privileged, its pleasures are secured precisely through the privilege of *proximate distance*.

A variety of discourses – ethnographic, sociological, literary, economic, political – construct certain territories, peoples, itineraries as objects for tourist experience. Through the tourist gaze, the work of other people/s and their accompanying rituals and festivals are refracted through the fictions of the picturesque, the exotic and the primitive. The fact of work, wage relations, commodity production, colonialism or imperialism are made irrelevant to the desired meanings of the scene. What is seen by the tourist becomes modern precisely because the social relations governing the encounter are displaced by representation of the concrete social scene as a *spectacle*, a spectacle of difference, which is, in fact, a way of fetishizing it.[64]

Within Europe, the countryside could only become material for touristic inscription by virtue of economic developments adequate to sustain the necessary infrastructure of transport, communication, accommodation and supplies of food. The country is therefore not brute difference – that would mean no amenities, no hotels, no cafés, no postal services and no company in the evenings. But while the country becomes a tourist spot precisely because it is caught up in global economic networks, it is ideologically invented as an absolute other to the city.

The Country is then an ideological figure of tourist ideologies. It does not express the real historical conditions which are equally altering rural

as well as urban life. It appears as the opposite – untouched, unchanged, simple, natural, wild, primitive, namely, non-modern. The Country becomes the terminus of a whole series of binary oppositions condensed in the terms City versus Country as absolutely opposite poles. As in all binary oppositions, there is hierarchy, with one term dominating its negated partner, which, in a fetishistic move, nonetheless exerts a powerful attraction precisely through its difference.

Dean MacCannell's book *The Tourist: A New Theory of the Leisure Class* begins with his encounter with the structural anthropologist Claude Lévi-Strauss (of *Tristes Tropiques* fame). In a lecture attended by MacCannell, Lévi-Strauss claimed that it was not possible to do an ethnography of modernity: modern society was just too complex; its structures had been smashed; it would be impossible to find some coherent system of relations in modern society of the kind that semiology had helped Lévi-Strauss to discover for what he called *La Pensée Sauvage*. MacCannell sets himself up to prove Lévi-Strauss wrong. The deep structure of modernity is, MacCannell argues, Tourism.

> The more I examined my data, the more inescapable became my conclusions that tourist attractions are an unplanned typology of structure that provides direct access to the modern consciousness or world view, that tourist attractions are precisely analogous to the *religious symbolism of primitive peoples* (my emphasis).[65]

In *The Tourist*, we are offered a structuralist reading of the 'mythology' of post-industrial society, comparable with that which Marxism provides for its predecessors, the industrial society. But while Marx focused on modes of production for his deep structure, MacCannell analyses a mode of *consumption* in which we are no longer defined by our work, or place in work relations. We are fundamentally formed through how we are organized in leisure and therefore in culture, and more specifically in our consumption of cultural experience which, of course, *pace* Marx, is a form of production.[66]

Tourism has to be linked historically both with the modernization taking place in the cities of modernity and with the colonialism and imperialism which produced the countries for the leisured and governing

classes of the cities of modernity to visit and exploit. Tourism, as MacCannell defines it, offers us a way to think about cultural forms and practices which articulate in their specific domains that which, in economic and political practices, we might call imperialism, or colonialism.

Tourism is, therefore, defined as a form of modernity. The structures and practices of tourism constitute a unifying consciousness by which the fragmented and complex forms of modern society can be reassembled, but in displaced form, as spectacle. Tourism has a specific class location. It is initially a product of the leisure practices of the middle classes who invented leisure in its modern form as a kind of consumption practised in regulated antithesis to the disciplines of productive labour. Leisure is the time which must equally be structured and filled – not with production but with consumption – eating, drinking, entertainment and, of course, seeing sights. Significantly, one of the major sights is the *labour of others* in non-modern systems of production – fishing folk, peasants in the fields,

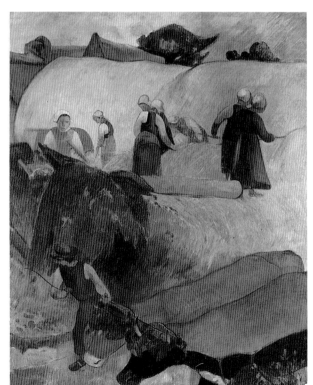

41 Gauguin,
Harvest in Brittany,
1889.

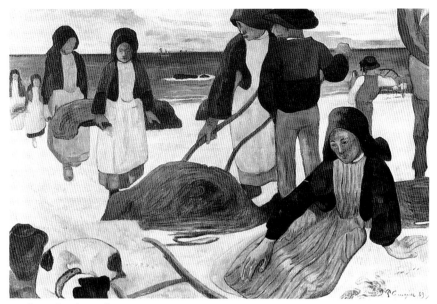

42 Gauguin, *Seaweed Harvesting*, 1889.

43 Bernard, *The Buckwheat Harvest*, 1888.

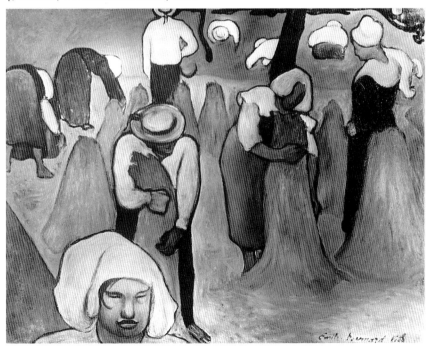

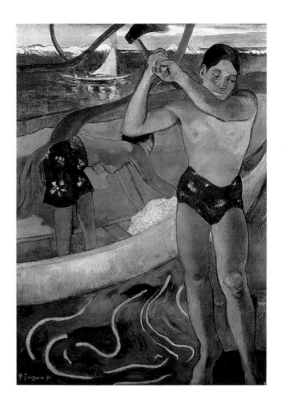

44 *Right* Gauguin,
The Man with an Axe,
1891.

45 *Below* Gauguin,
*Gathering Fruit
in Martinique*, 1887.

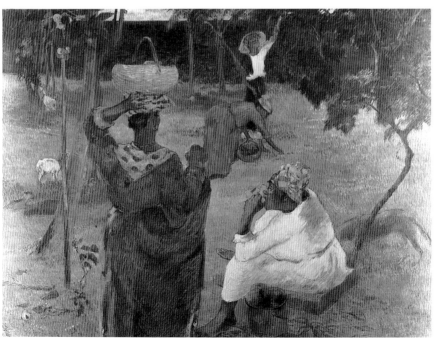

Bretons harvesting or collecting seaweed, Tahitians picking mangoes, 41–45 and so forth. People from a certain class and culture have time and the surplus money to travel to other places where other classes and peoples are watched *while they work*. But what they do does not signify 'work', in its modernized, capitalist sense. It is not waged labour; it seems to obey other rhythms and necessities. It is therefore not perceived as work but as seasonal tasks, obedient to natural cycles rather than to social relations.[67] The modern (or the historical consciousness called modernity) is formed precisely by being experienced in temporal and cultural difference from what is perceived as the pre-modern or non-modern.

MacCannell argues that 'the deep structure of modernity is a totalizing idea, a modern mentality that sets modern society in opposition both to its own past and to those societies of the present that are pre-modern or underdeveloped.'[68] He stresses that 'no other major social structural distinction (and certainly not that between the classes) has received such massive reinforcement as the ideological separation of the modern from the non-modern world.'[69] This involves, however, not the destruction of the non-modern world, but its artificial preservation and reconstruction as a spectacle for modern, tourist society.[70] Certain traits 46

46 At the Universal Exhibition in Paris in 1889 (*right*), which commemorated the centennial of the Revolution, a major display of colonialism included the reconstruction of villages from the colonies, complete with their inhabitants performing traditional crafts. Gauguin's trip to the Tropics was much influenced by these 'sights' in the heart of Paris, though he had already been to Martinique in 1887.

of the non-modern are selected and detached from their signifying place within their own socio-economic and cultural system. These emblems, as it were, of non-modernity, of difference – fetishes perhaps – are then circulated as signs in tourist mythologies.[71]

But MacCannell's theses on the tourist invite a greater degree of subtlety than this stark if justified condemnation of what Gayatri Spivak, writing of British imperialism in Northern India, calls 'epistemic violence'.[72] While MacCannell defines the tourist attraction, he also discusses the *tourist's attraction*, namely, what captivates the tourist. This is a desire to reclaim a cultural identity by which to overcome difference, and distance, so as to find roots in the past, for instance, in order to recoup continuities in place of modernity's discontinuities, collectivities in place of modernity's intensified individualities.

The spectacle the tourist seeks is shaped as a compensatory belief in the possibility of simple, direct meaning, namely, that which the European metropolitan experience of modernity so systematically disturbs. Thus MacCannell argues that

... sightseeing is a ritual performed to the differentiations of society. Sightseeing is a collective striving for a transcendence of the modern totality, a way of attempting to overcome the discontinuity of modernity, of incorporating its fragments into a unified experience. Of course it is doomed to failure; even as it tries to construct totalities, it celebrates differentiation.[73]

This 'structuralist' anatomy of tourism is extremely apposite and suggestive in thinking about the peculiar structures of emergent modernism which we encounter in the art of the late nineteenth century, epitomized around the artist as tourist and the strategies of Gauguin in Tahiti. Tourism operates in the macrocosm of modernity as a whole in a way which can be paralleled in the micro-community of the Parisian avant-garde. The avant-garde project begins at the heart of modernity, the city which was called by Walter Benjamin the capital of the nineteenth century. By the 1880s the avant-garde could no longer sustain its engagements, however equivocal, with the social and urban forms of modernity. To do so would have required Pissarro's trenchant politics and siding with revolution. MacCannell defines tourism as the antithesis

of revolution, the non-revolutionary response to that crisis of social consciousness about the social totality which so exploded on the streets of Paris in the 1890s bombing campaigns and in the anti-semitism and nationalist politics of the Dreyfus affair, to name but two of the overt signs of crisis at the end of the last century. Through tourism, the labour, the social forms and cultural belief systems of other societies are made into signifiers of the metropolitan tourist's search for a missing totality and a closed history, a resistance against modernity's insistent creation of discontinuity and fragmentation.

Cultural representations produced within this scheme of modernity as tourism would, however, always produce difference, that sign of distance, dread and disavowal whose ambivalent underside is fascination and desire. The balancing act for the colonial masculine subject as artist could only be achieved by an ultimate assertion of aesthetic mastery over the impossible object of desire, an escape not just from the facts of sexual difference and the laws of subjectivity, but an escape from history and the laws of capitalist production. Fetishism was identified by Freud as a key defence mechanism of the psyche against undesirable acknowledgment. Avant-gardism's fetish was its own procedures: the facture, the style, art itself as just a matter of colour and lines on a flat surface.

Gauguin as Tourist

Gauguin's trips to Tahiti made him a particular kind of tourist, part of an advance guard, the eyewitness reporter. He went officially as a Frenchman to a French colony with the aid of the French government. He occupied a precarious but nevertheless political position of power which authorized him to look and to represent what he saw within that interface of administrative, ethnographic and touristic gazes. What did that gaze say?

I'm talking about wimmen! I like my women fat, stupid and vicious with nothing spiritual. To say I love you would break my teeth.[74]

That gaze is inscribed in and made public by the painting *Manao* 8
Tupapau. But, as I have already indicated, it was deeply risky to make it

the condition of an avant-garde gambit. On 8 December 1892 Gauguin wrote about the painting of his Tahitian wife to his Danish wife.

I have painted a young girl in the nude. In this position, a trifle more, and she becomes indecent. However, I want it in this way as the lines and movement interest me. So I make her look a little frightened. This fright must be excused if not explained in the character of the person, a Maorie [*sic*]. This people have by tradition a great fear of the spirit of the dead. One of our own young girls would be startled if surprised in such a posture. Not so a woman here.[75]

Later in the letter, after explaining its coloration in detail as the means by which it ceased to be indecent, Gauguin concludes:

Here endeth the little sermon, which will arm you against the critics when they bombard you with their malicious questions. To end up the painting has to be done quite simply, the *motif* being savage and childlike.[76]

Gauguin anticipated not merely hostile criticism, based on differing concepts of aesthetic propriety. He was apprehensive about *malicious* comments, the choice of word being extremely revealing of the underlying guilt. Mette Gauguin was to be 'armed' with a spurious religious explanation for the pose, a woman transfixed by fear of the spirit of the dead. Yet her look locates the source of the threat in the gaze of the viewer at her rudely exposed body. Gauguin's tourist narrative infantilizes the whole complex structure of ancestor worship and reduces it to a matter of superstition. Is there not more than an echo here of that rustic and superstitious simplicity with which Gauguin the tourist in Brittany characterized the peasant woman in another 'sermon'? However tenuous the linguistic link between this letter and the title of the painting of 1888, I suggest that these paintings inhabit a comparable ideological space.

Uncomprehending and unable to imagine the meaning or purpose of the belief systems of social and cultural others, the bourgeois European's fascination with what he desires but cannot have is recouped by projection onto an infantilized and primitivized woman. She is thus made sign of a culture which is distanced and subdued, put in its place like a native child – wild, primitive and superstitious, but desirable. By

35

68

means of its uses of Western hierarchies of sexual difference in which the polarity self/other reads as male/female, the painting further writes onto that scene a regime of racial difference, for which primitivism and exoticism are the aesthetic syntax.

The debates we might have about Bernard and Gauguin in Brittany (and to a lesser extent about Van Gogh in Provence) could produce several different positions. The artists might be crudely characterized as insensitive outsiders appropriating Breton forms and customs for their metropolitan game-play. They could be tourists mis-recognizing the locality because of too uncritical a consumption of tourist clichés about this remote and ancient province. There may be genuine desire to found a practice in something less complex than the city, something less crudely exposed to the penetration of the commodity. These can be imagined as part of the baggage with which these artists travelled, the attitudes which shaped their practice and their accounts of it. The aspect which I want to emphasize is the effect that we do not need to speculate about: the need to insert themselves into their own work, either through the self-portraits in

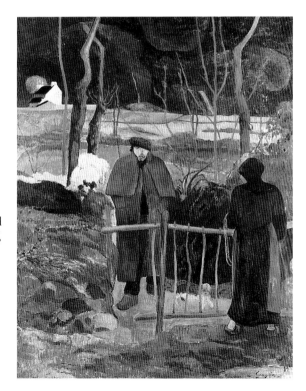

47 Gauguin, *Bonjour, Monsieur Gauguin*, 1889. This title defers to a work by another major figure of the new art movement, Gustave Courbet's *Bonjour, Monsieur Courbet* (1854). Courbet's strategies included the calculated positioning of himself, the artist, within the histories he ambitiously painted. Gauguin's reprise reduces to self-pitying posturing.

such paintings as *Vision after the Sermon*, *Christ in the Garden of* 47 *Gethsemane* and *Bonjour, Monsieur Gauguin*, or in the idiosyncratic stylizations which served as self-advertisement. The artist's own work (meaning both object and the labour which produced it) itself becomes a signifier of the artistic subject who produced it. This insertion of the artist into the image at both these levels indicates a need to make authentic that which, by being a modernist work, by turning a sight into a spectacle, was deprived of its own authenticity, what Benjamin would call its aura – its historical, cultural and social specificity. Thus the artistic tourist journeys here and there in search of an origin in apparently pre-modernist societies and cultures, which can only momentarily appear as sites of authenticity. Just because they were being recast as spaces of avant-garde representation, they were violently modernized. The condition of the avant-garde gambit is the infrastructure of the economic and political colonization, which is itself then fetishized, that is, disavowed through the aesthetic refashioning of those spaces as 'la peinture consolante'.

Manao Tupapau is a complex play of reference, deference and difference. It signifies its play with Manet's *Olympia* (1863) as much as with Gauguin's earlier work, *Vision after the Sermon* (1888). But Gauguin's anxiety about its reception in Paris in 1893 is in pointed contrast to the trouble caused by *Olympia*'s modernity when it was exhibited in 1865. Gauguin's choice of posture for his model Teha'amana not only betrays Manet's calculated strategy of rupture vis-12, 13 à-vis both the Venetian and the orientalist nude but does so in a way which evidently caused the artist anxiety. What else is the letter to Mette Gauguin than a worried attempt to pre-empt criticism, already registering the shock of that display of a vulnerable body, its invitation to *a tergo* sex? The artist Gauguin so admired, Degas, at least never 48 exhibited his comparable fantasies. Gauguin manages the problem by calling his explanation a sermon – after which men may fantasize like the women in the *Vision* perhaps. He also constantly inscribes a racial difference between European women – his daughters – who would feel ashamed to be seen thus and Tahitian women, who apparently do not experience such modesty. This textual evocation of two types of women reveals the structural 'European' position of the writer, for whom the

70

48 Degas, *Nude Woman Lying on a Sofa*, 1885. Gauguin admired Degas greatly, and Degas returned the compliment by purchasing Gauguin's copy of Manet's *Olympia*, 1890–91, ill. 10.

behaviour and dress of the Tahitian women is sexualized precisely by being implicitly contrasted to European codes of femininity – those who do and those who don't, the feminine/sexual. Nonetheless, it is clear whose will prevails in the end: Gauguin wanted it like that. *He* liked the lines and the movement. Any possible sensibility on the part of the Tahitian woman is sacrificed to that urgency, the aesthetic gambits of the European male avant-garde.

Her body is appropriated to signify his desire as white man and artist. Any thought about Teha'amana, the Tahitian woman as subject – as a historically constituted and culturally specific feminine subjectivity – falls under his erasure. Like Fanon's experience of being seen, and thus seeing himself, in the mirror of white perception, she is re-presented to herself as object, her Tahitian and female body spattered with his coloration, his fantasy, his historical practice of 'sexuality'.

The moment of the production of this painting, the conditions of its possibility, are those of the modernity of the West. It is a European man looking. Under that gaze and the desire it writes upon the body of the woman bought to service the artist in bed and on it, Tahiti is but a dead phantom evoked by Gauguin to muddle and confuse, an alibi which does not wash. The pre-modern or the non-modern cannot be conserved in the midst of the modern. That is the tourist fantasy of the trip to the South Pacific. The reality is that anything the Europeans have touched is contaminated by their money and disciplined by their gaze, imprinted with their power, and shaped by their desire. At this point, where tourism rides on colonialism, and art circulates on the latter's ships, we can see the over-determined conjuncture of cultural and sexual difference, and their mutual interface: sex and race at the heart of

49, 50 capitalism's imperial process.

The art history which continues uncritically to celebrate these great masters and to affirm Gauguin's self-curating strategies – his avant-garde gambits – only confirms its collaboration with that European project, exposing not only the gender, but also the colour of art history.

49 Gauguin, *Nevermore, O Tahiti*, 1897.

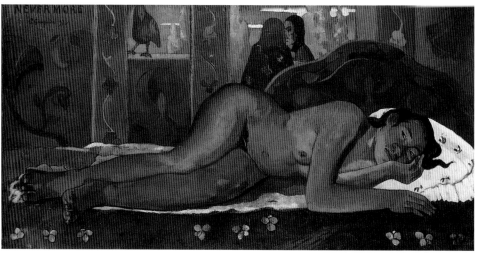

72

50 Page 57 of the Louvre manuscript of *Noa Noa*. A possible photograph of Teha'amana (*top right*), captured in the format of the Western portrait, with a cross mingling with traditional jewellery on her naked chest, finds itself in the company of two images which represent Gauguin's quest on his tropical journey. Juxtaposed with a Gauguin woodcut of imaginary Tahitian deities is a watercolour re-staging a kind of *Susanna and the Elders* in a tropical Eden, the naked Eve figure watched by a satyr-like creature grasping the tree (of the Knowledge of Good and Evil?).

NOTES

1 In my article, 'Lust for Death: Cinema and the Myth of Van Gogh', forthcoming in *The Mythologies of Van Gogh*, ed. Tsukasa Kodera (Tokyo: TV Asahi, 1992), I explore Minnelli's representation of Van Gogh through composite negations of effeminacy, hysteria, invalidism and madness which de-legitimates him as an artist; his mantle falls firmly onto an empowered Gauguin.

2 Carol Duncan, 'Virility and Male Domination in Early Twentieth-Century Vanguard Art', *Art Forum* (December 1973): 30–39; reprinted and revised in *Feminism and Art History*, ed. Norma Broude and Mary D. Garrard (New York: Harper and Row, 1982).

3 The notion of a 'studio of the Tropics' occurs in Van Gogh's letters and then becomes a theme in those of Gauguin, especially to Emile Bernard, whom he hoped to attract to his project for an artistic colony first in Madagascar and then in Tahiti. See Maurice Malingue, ed., *Lettres de Gauguin à sa femme et ses amis* (Paris: Bernard Grasset, 1946), Letter 105, *c.* 1890, p. 191.

4 The term 'primitivism' and the political and cultural agendas it signifies have been powerfully critiqued through such journals as *Third Text*; James Clifford, 'Histories of the Tribal and the Modern', in his *The Predicament of Culture* (Cambridge, Mass.: Harvard University Press, 1988); in a Ph.D. dissertation in progress at the Courtauld Institute of Art by Petrine Archer Shaw, in which she substitutes the term 'primitivizing' for 'primitivist' and 'negrophilia' for 'primitivism'. See also abstracts from *Subversions/Objects*, Association of Art Historians Annual Conference, Leeds, 1992, p. xx. The theme of the tropical journey runs strongly through from Baudelaire to Claude Lévi-Strauss, *Tristes Tropiques* (Paris: Librairie Plon, 1955; New York: Atheneum, 1974, trans. J. and D. Weightman).

5 Sigmund Freud, 'Creative Writers and Daydreaming' [1908], *Art and Literature*, vol. 14, Pelican Freud Library (London: Pelican Books, 1985).

6 Valerie Amos and Pratibha Parma, 'Challenging Imperial Feminism', *Feminist Review* 17 (1984): 3–20.

7 Richard Dyer, 'White', *Screen* 24, no. 1 (1988): 46. Adrian Piper's work can be studied in the catalogue of the retrospective exhibition originating from the Ikon Gallery, Birmingham, and travelling around Britain in 1991–92.

8 The fullest narrative of these events is to be found in Bengt Danielsson, *Gauguin in the South Seas*, trans. Reginald Spink (London: George Allen & Unwin Ltd, 1965).

9 Emile Verhaeren, 'Le Salon des Indépendants', in *La Nation*, 1891, cited in John Rewald, *Post-Impressionism* (New York: Museum of Modern Art, 1956; London: Thames and Hudson, 1978), p. 7.

10 The umbrella under which critics and public could contain such diversity, while recognizing its collective difference from other artistic communities, was the 'new art', coined by Edmond Duranty in a review of the second Impressionist exhibition in 1876.

11 Miriam R. Levin, *Republican Art and Ideology in Late Nineteenth Century France* (Ann Arbor, Mich.: UMI Research Press, 1986).

12 Danielsson (note 8) discusses Gauguin's limited grasp of the language and his incorrect Tahitian titles.

13 In *Noa Noa*, Gauguin tells a story about his first companion in Tahiti: 'She looked with particular interest at a photograph of Manet's Olympia. She told me that this Olympia was truly beautiful: I smiled at that opinion and was moved by it . . . She added, all of a sudden, breaking the silence over a thought: "It's your wife." "Yes," I lied. Me, the *tane* of Olympia!' Paul Gauguin, *Noa Noa, Voyage to Tahiti*, trans. Jonathan Griffin (Oxford: Bruno Cassirer, n.d.), p. 21.

14 Hélène Cixous, trans. Annette Kuhn, 'Castration and Decapitation', *Signs* 7 (1981), pt. 1, pp. 41–55, p. 43.

15 Timothy J. Clark has argued that despite the seeming obviousness for us of the reference only one critic in 1865 stated the connection; either it was invisible or Manet's painting was perceived as too corrupt a quotation of that tradition of the desirable nude to be spoken of in the same terms. Timothy J. Clark, 'Preliminaries to a Possible Treatment of *Olympia* in 1865', *Screen* 3, no. 1 (1980): 18–43.

16 Sigmund Freud, *Totem and Taboo* [1919] (London: Pelican Books, 1938), is the classic statement of this psychological formation in an anthropological context.

17 Thadée Natanson, 'Expositions: Oeuvres Récentes de Paul Gauguin', *La Revue blanche* 5, no. 26 (1894): 421. Roger Marx asked in his review, 'Is it a polynesian *Olympia*?', cited in Belinda Thomson, *Gauguin* (London: Thames and Hudson, 1987), p. 175.

18 Alfred Jarry, *Oeuvres complètes* (Paris: Gallimard, 1972), pp. 254–55.

19 See Christopher Miller, *Blank Darkness: Africanist Discourse in French* (Chicago: University of Chicago Press, 1985).

20 I use the word 'imaginary' in the sense of the French 'imaginaire', to refer not to a faculty but to a 'set of images', an ensemble. Imaginary is a specific term differentiated from the Romantic concept of Imagination precisely because it is linked, in psychoanalytical usage, with the unconscious and its *imago*es. It has entered contemporary cultural theory mostly through the work of the Russian literary theorist, Bakhtin.

21 Cleo McNelly, 'Nature, Women and Claude Lévi-Strauss', *Massachusetts Review* 16 (1975): 9. This section is deeply indebted to McNelly.

22 *Ibid.*, p. 10.

23 *Ibid.*, p. 11.

24 McNelly can offer another level of insight into the minute differentiations of colour and their meaning in the register of desire. In a section about the primacy of touch in the fantasy of the Tropics, and the ambivalence of attraction and disgust, she quotes Lévi-Strauss: 'Their skin is darker, too: many are afflicted with skin diseases that cover their entire bodies with patches of violet, but among those not so affected, their skin is powdered with sand in which they love to roll themselves; this gives it, after a time, a look and feel of velvety beige, which can, above all in the case of the younger women, be enormously attractive,' p. 15. (Claude Lévi-Strauss, *Tristes Tropiques* [1955], trans. J. and D. Weightman [New York: Atheneum, 1974]), p. 276.

25 Paul Gauguin, *Noa Noa*, manuscript in the Louvre, pp. 109–110, cited in Richard Brettell *et al.*, *The Art of Paul Gauguin* (New York: Graphic Society, 1988), p. 280.

26 Linda Nochlin has argued that this is a consistent device of European orientalist painting. Discussing Gérôme's *Snake Charmer* (1860s, Williamstown, Francine and Sterling Clark Institute), she notes the use of an audience within the painting composed of locals for whom the young boy appears to perform, while the painting is framed, as a whole, for both boy and simple-minded audience to function as a spectacle of otherness for the protected, invisible but mastering gaze of the European viewer. See Linda Nochlin, 'The Imaginary Orient', in Linda Nochlin, *The Politics of Vision: Essays on Nineteenth-Century Art and Society* (London: Thames and Hudson, 1991).

27 Emile Zola in his famous 'Edouard Manet', *L'Artiste: Revue du dix-neuvième siècle*, 1 January 1867, which was reprinted as a brochure, *Manet: Etude biographique et critique* (Paris: Georges Charpentier, 1867).

28 Paul Gauguin, 'Genèse d'un tableau', in unpublished *Cahier pour Aline* (c. 1892), Bibliothèque d'Art et d'Archéologie, Paris Fondation Jacques Doucet, facsimile ed. Suzanne Damiron, Paris 1963. Translation used here from Brettell *et al.* (note 25), p. 281.

29 I am grateful to Professor Tom Crow for emphasizing this structure in Gauguin's conflict over the potential meaning of the painting. It reveals his confusion when his own sexual mythologies were confronted by the practices and sexualities of another culture. In *Noa Noa*, Gauguin wrote about his idyllic life with his young Tahitian wife. 'The gold of Tehaurana's [*sic*] face flooded all about it, and the two of us would go naturally, simply as in Paradise, to refresh ourselves in a neary-by stream, *fenua nave nave*. The life of everyday – Tehaurana yields herself daily more and more, docile and loving. Tahitian *noa noa* pervades the whole of me. I am no longer conscious of the days and of the hours, of Evil and of Good – all is beautiful; all is well.' Paul Gauguin, *Noa Noa*, trans. Jonathan Griffin (Oxford: Bruno Cassirer, n.d.), p. 38. This reads like Eden regained, and the absence of good and evil refers explicitly to the prelapsarian moment, which paradoxically inscribes its opposite, the Fall and a specifically Catholic consciousness of its meaning. However much Gauguin wanted to escape, his Utopia was embedded in a structure of Western meanings – and his sexuality only operated through reference to it.

30 This argument was originally developed in collaboration with Fred Orton in our article, 'Les Données Bretonnantes: La Prairie de Représentation', *Art History* 3, no. 3 (1980): 314–44.

31 For a fuller explanation of this argument, see my 'Distanced Creations: Post-impressionism',

in Denise Hooker, ed., *Art of the Western World* (London: Box Tree, 1989).

32 See Mark Roskill, *Van Gogh, Gauguin and the Impressionist Circle* (London: Thames and Hudson, 1970), for full documentation of this preoccupation with Seurat.

33 Félix Fénéon, 'L'Exposition Volpini', *La Cravache*, 6 July 1889, reprinted in Françoise Cachin, *Félix Fénéon: Au delà de l'Impressionnisme* (Paris: Miroirs de l'Art, 1966), p. 110.

34 Camille Pissarro, *Letters to His Son Lucien*, ed. John Rewald (Marmoreck, N.Y.; Paul P. Appel, 1972), p. 221. The full passage reads: 'Gauguin's present show is the admiration of the men of letters. They are, it appears, completely enthusiastic. The collectors are baffled and perplexed. Various painters, I am told, all find this exotic art too reminiscent of the Kanakians. Only Degas admires, Monet and Renoir find all this simply bad. I saw Gauguin; he told me his theories about art and assured me that the young would find salvation by replenishing themselves at remote and savage sources. I told him that this art did not belong to him, and he was a civilised man and hence it was his function to show us harmonious things. We parted, each unconvinced. Gauguin is certainly not without talent, but how difficult it is for him to find his own way! He is always poaching on someone's ground; now he is pillaging the savages of Oceania'.

35 Abigail Solomon-Godeau, 'Going Native', *Art in America* (July 1989): 119–128/161.

36 See my 'Modernity and the Spaces of Femininity', in *Vision and Difference: Feminism, Femininity and Histories of Art* (London: Routledge, 1988).

37 Paul Gauguin, *Noa Noa* (Oxford: Bruno Cassirer, n.d.), p. 36. See a detailed discussion of this episode in Danielsson (note 8), 'The Marriage of Koke', pp. 107–112.

38 See Gauguin's letter to Emile Bernard, written from Le Pouldu in Brittany in June 1890, about the possibility of a studio in the Tropics whose main appeal is that needs can be satisfied without recourse to money. 'I shall go and live there like a man retired from the civilised world, who intends to mix only with so-called savages. And of my daily bread I will place half at your disposal. *A woman out there is, so to speak, obligatory*, which will provide me with an everyday model.' Malingue (note 3), Letter 105, p. 192.

39 There are some accounts of how Tahitian women lived with men before they were married, but these were free unions between unattached adults. To live with a married man would rate as prostitution. Gauguin did not tell Teha'amana he was still married in Europe. Indeed, he was preparing to paint his Tahitian wife and then send the paintings to his Danish wife, who would arrange their exhibition. Gauguin was in regular correspondence with Mette Gauguin throughout his time in Tahiti, planning their possible reunion. Teha'amana was not Gauguin's only consort. In 1944 Eric Ramsden published a short article on the recent death of 'Paul Gauguin's Tahitian Mistress' (*Pacific Islands Monthly*, January 16, 1944, pp. 22–23). On his return to Tahiti in 1895 Gauguin first summoned Teha'amana but she refused to live with him in his syphilitic state. He then 'married' Pau'ura a Tai, born 27 June 1881, when she was fourteen. During their ten-year relationship, she bore him two children, a daughter who died in infancy and a son, Marae a Tai, who in 1944 was a grown man supporting his mother as a fisherman. Neither had received anything from Gauguin; 'Her poverty was pathetic', writes Ramsden.

40 Luce Irigaray, 'Women on the Market', *This Sex Which Is Not One*, trans. Catherine Porter (Ithaca, N. Y.: Cornell University Press, 1985).

41 This was revealed as a widespread scandal in Britain in the 1880s in W. T. Stead's campaigning articles, 'Maiden Tribute of Modern Babylon', *Pall Mall Gazette*, 6 July, 1885, p. 2; 28 July, 1885, p. 1. See also Deborah Gorham, 'The "Maiden Tribute of Modern Babylon" Reexamined: Child Prostitution and the Idea of Childhood in Late Victorian England', *Victorian Studies* 21, no. 3 (1978). In Britain the age of consent rose from 12 in 1861, to 13 in 1875, to 16 in 1885.

42 For a major and innovative re-reading of the Venus-nude at the Salon, see Jennifer L. Shaw, 'The Figure of Venus: Rhetoric of the Ideal and the Salon of 1863', *Art History* 14, no. 4 (December 1991): 540–71.

43 I am using the term in its specifically Foucauldian sense. In his *History of Sexuality*, vol. 1 (London 1978), Michel Foucault argues firstly that sexuality is a historical construct, an effect of an array of inter-related discourses and apparati, bound up with relations of power and

knowledge, and secondly that it is a class formation, originating with the bourgeoisie and in its wider deployment having distinctive class effects, p. 127.

44 Linda Nochlin identifies the orientalist painting as one which absents history and makes time stand still. Thus the European colonizing nation presents itself as the forward progressive thrust of historical movement justified in its invasion and refashioning of cultures frozen in their decaying pasts. Nochlin (note 26), 'The Other Imaginary', pp. 35–36. The founding text on the issue is Edward Said, *Orientalism* (London: Routledge and Kegan Paul, 1978). See also Bernard Smith's important work on the initial perceptions of the Europeans who first visited the South Seas in the eighteenth century and how these altered as discovery was replaced by colonial motives, *European Vision and the South Pacific* (London: Yale University Press, 1985).

45 See my forthcoming *Sexuality and Surveillance: Bourgeois Men and Working Women* (London: Routledge) for a further account of the image of peasant women.

46 In 1898 Gauguin exhibited another Tahitian painting, *Te Arii Vahine* (1896: 'The Noblewoman'), whose pose bespoke its reference enough to be called by Julien Leclercq 'Olympia Noire'. Incidentally, this work was to be shown alongside *Manao Tupapau* in Stockholm, but the latter had to be withdrawn on moral grounds.

47 Franz Fanon, *Black Skins, White Masks* [1952], ed. Homi Bhabha (London: Pluto Press, 1986), p. 113.

48 Homi Bhabha, 'Foreword: Remembering Fanon: Self, Psyche and the Colonial Condition', in Fanon (note 47), p. x.

49 *Ibid.*, pp. xiv–xv.

50 Sigmund Freud, 'Fetishism' [1927], in *On Sexuality* (London: Pelican Books, 1977), pp. 345–58.

51 Fanon (note 47), p. 112.

52 *Ibid.*

53 This theme is also to be found in Van Gogh's letters, in the poetry of Baudelaire and in the Utopian imagery of Matisse, who cited Baudelaire in his painting *Luxe, Calme et Volupté* (1904–05).

54 I have drawn upon Homi Bhabha, 'The Other Questions: The Stereotype and Colonial Discourse', *Screen* 24, no. 6 (1983), but looked at it from a slightly different angle, specifying the male colonizer's fantasy. Bhabha stresses the ambivalence of colonial discourse which allows us to perceive the desire which is invested in what otherwise would only appear one-sidedly as a will for mastery, leaving the colonial subject to his fantasy of wholeness, rather than fissured and dependent on the colonized as equally caught up in their reciprocal subjectivities. From the point of view of the colonized, however, the fetishization of skin/colour is more difficult to negotiate. The fetish works as an arrested meaning, a fixing of the racial other to a stereotype which seems bound to the visible sign of difference, the darker skin, which is then tied into 'the signifieds of a racial typology, the analytics of blood, the ideologies of racial and cultural dominance or degeneration', pp. 27–28.

55 Gayatri Chakravorty Spivak, 'Imperialism and Sexual Difference', *Oxford Literary Review*, no. 1/2 (1986).

56 For a fuller discussion of their relations to other artists who colonized Brittany for the Salon, see Orton and Pollock (note 30).

57 *The Complete Letters of Vincent Van Gogh* (London: Thames and Hudson, 1959), Letter 595, vol. III, p. 182.

58 This City/Country opposition is radically different from earlier moments in his career in 1883 when a similar move was made from The Hague to Drenthe and Brabant. This actual countryside provided access to Van Gogh's historical memory of a childhood past which was also the pre-modern past of the countryside. For a fuller discussion, see my forthcoming book, *The Case Against Van Gogh: The Cities and Countries of Modernism* (London: Thames and Hudson).

59 This is a very compressed version of the argument advanced in my Ph.D. dissertation, *Van Gogh and Dutch Art: A Study of Van Gogh's Concept of the Modern*, London University, 1980.

60 On Theo Van Gogh as a dealer, see John Rewald, 'Theo Van Gogh, Goupil and the Impressionists', *Gazette des beaux arts* 115, no. 1248 (1873): 1–64; no. 1249 (1973): 65–108; and David Cooper, *Paul Gauguin: 45 Lettres à Vincent, Theo et Jo Van Gogh* (Amsterdam: Staatsuitgeverij, La Bibliothèque des Arts, 1983).

61 For a fascinating analysis of this text, see Roland Barthes, 'The Struggle with the Angel', in *Image-Music-Text*, trans. Stephen Heath (London: Fontana Books, 1977).

62 *Complete Letters* (note 57), Letter to Bernard, 21, vol. III, pp. 524–25.

63 Dean MacCannell, *The Tourist: A New Theory of the Leisure Class* (New York: Schocken Books, 1976; London: Macmillan Press Ltd, 1976).

64 I am indebted here to Timothy J. Clark's important formulations about modern art and the spectacle, as argued in his *Paintings of Modern Life: Paris in the Art of Manet and His Followers* (New York: Knopf; London: Thames and Hudson; 1984).

65 MacCannell (note 63), p. 2.

66 I am thinking here of Marx's analysis of productive consumption in the 'Introduction' to *Grundrisse*, ed. Martin Nicolaus (London: Pelican Books, 1973). MacCannell's revised theory of leisure and class parallels others – situationists and new leftists – who since the 1950s have been forced by the very developments of advanced capitalist societies to reckon with the cultural/ ideological realm as much more than a superstructure or epiphenomenon. The ideological/ cultural complex is acknowledged for its effectiveness in securing relations of domination, in producing subjectivities in ordered regimes of gender, race and, residually, class. Through cultural practices of an extensive range, the very fabric of the reality we inhabit is manufactured – the cultural script by which we live produced. Consciousness is, therefore, indelibly social, and organized by, as well as eloquent of, the structures of inequality of class, race and gender.

67 On the changing meanings of the concept 'work', see Raymond Williams, *Keywords* (Glasgow: Collins, 1976).

68 MacCannell (note 63), p. 8.

69 *Ibid.*

70 It is relevant here to recall the complete villages and their inhabitants transported from across the colonized world to Paris for the Universal Exhibition of 1889, an influential sight for Gauguin, whose idea for his tropical journey was reinforced by this domestic and vicarious tourism experienced through the spectacle of the world fair. See Burton Benedict, *The Anthropology of World's Fairs* (London and Berkeley, Calif.: The Scolar Press, 1983) and Debora Silverman, 'The 1889 Exhibition: The Crisis of Bourgeois Individualism', *Oppositions* (1977): 71–91.

71 I use the term advisedly, drawing on Roland Barthes's analysis of bourgeois ideology as 'mythology'. In his essay 'Myth Today' in *Mythologies* [1957], trans. Annette Lavers (London: Paladin Books, 1972), Barthes provides a semiological reading of the operation of bourgeois mythologies as a dual system, in which signs with concrete meanings in their historical and social context are borrowed, emptied of their specificity and refilled by ideological connotations, which then masquerade as a kind of truth because they are dressed in the 'naturalism' of the borrowed denotational signs. The denotational signs of agriculture or food gathering in Tahiti or Brittany are taken over and filled with touristic and colonial meanings, while appearing in that latter discourse as natural, factual statements about the timeless tasks of 'Man' in 'Nature'.

72 Gayatri Chakravorty Spivak, 'The Rani of Sirmur', *History and Theory* 8 (1985): 247–72. By this term Spivak means violence done to a people or culture when they are drawn into another, dominating culture's system of knowledge. Known only through a colonizing discourse, they are subjected to a violation as effective as a physical subordination.

73 MacCannell (note 63), p. 13.

74 *The Intimate Journals of Paul Gauguin*, trans. Van Wyck Brooks (London: William Heinemann, 1923), p. 2.

75 Paul Gauguin, *Letters to His Wife and Friends*, ed. Maurice Malingue, trans. Henry J. Stenning (London: The Saturn Press, 1949), Letter 134, pp. 177–78.

76 *Ibid.*, p. 178.

LIST OF ILLUSTRATIONS

Measurements are given in centimetres and inches, height before width.

Art Institute of Chicago, Charles Dee, ring McCormick Collection

26 Photograph of Auguste Goupil's daughters, Punaauia, Tahiti

27 ALEXANDRE CABANEL, *The Birth of Venus*, 1863. Oil on canvas, 129.5 × 111.5 (51 × 43$\frac{7}{8}$). Musée du Louvre, Paris. Photo Giraudon

28 TITIAN, *Sacred and Profane Love*, *c.* 1575. Oil on canvas, 108 × 256 (42$\frac{1}{2}$ × 100$\frac{3}{4}$). Borghese Gallery, Rome

29 EDGAR DEGAS, *Women in front of the Café, Evening*, 1877. Pastel over monotype, 41 × 60 (16 × 23$\frac{1}{2}$). Musée d'Orsay, Paris. Photo Réunion des musées nationaux

30 JULES BRETON, *Calling the Gleaners Home*, 1859. Oil on canvas, 45 × 65 (17$\frac{3}{4}$ × 25$\frac{5}{8}$). Musée d'Arras. Photo Alinari-Giraudon

31 VINCENT VAN GOGH, *The Starry Night*, 1889. Oil on canvas, 73 × 92 (29 × 36$\frac{1}{4}$). Collection The Museum of Modern Art, New York. Acquired through the Lillie P. Bliss Bequest

32 VINCENT VAN GOGH, *Mountainous Landscape behind St Paul's Hospital*, 1889. Oil on canvas, 70.5 × 88.5 (27$\frac{3}{4}$ × 34$\frac{7}{8}$). Ny Carlsberg Glyptotek, Copenhagen

33 EMILE BERNARD, *Women in a Meadow*, 1888. Oil on canvas, 74 × 92 (29 × 36$\frac{1}{4}$). Private collection. Photo Giraudon

34 PAUL GAUGUIN, sketch of *Vision after the Sermon* in a letter to Van Gogh, 22 September 1888. 11.7 × 15.5 (4$\frac{5}{8}$ × 6$\frac{1}{8}$). Vincent van Gogh Foundation/Van Gogh Museum, Amsterdam

35 PAUL GAUGUIN, *Vision after the Sermon* (Jacob Wrestling with the Angel), 1888. Oil on canvas, 73 × 92 (28$\frac{3}{4}$ × 36$\frac{1}{4}$). National Galleries of Scotland, Edinburgh

36 PAUL GAUGUIN, *Women in the Public Garden*, 1888. Oil on canvas, 73 × 91.5 (28$\frac{3}{4}$ × 36). Art Institute of Chicago. Mr and Mrs Lewis L. Coburn Memorial Collection

37 PAUL GAUGUIN, *The Yellow Christ*, 1889. Oil on canvas, 92 × 73 (36$\frac{1}{4}$ × 28$\frac{7}{8}$). Albright-Knox Art Gallery, Buffalo, General Purchase Funds, 1946

38 PAUL GAUGUIN, letter from Gauguin to Van Gogh, 8 November 1889 with sketches of *Soyez amoureuses* and *Le Christ au Jardin des Olives*. Vincent van Gogh Foundation/Van Gogh Museum, Amsterdam

39 PAUL GAUGUIN, *Christ in the Garden of Gethsemane*, 1889. Oil on canvas, 72.5 × 91.5 (28$\frac{1}{2}$ × 36). Norton Gallery and School of Art, West Palm Beach, Florida

40 EMILE BERNARD, *The Annunciation*, 1889. Oil on canvas, 44.4 × 53.3 (17$\frac{1}{2}$ × 21). Collection Stuart Pivar

41 PAUL GAUGUIN, *Harvest in Brittany*, 1889. Oil on canvas, 92 × 73 (36$\frac{1}{4}$ × 28$\frac{3}{4}$). Courtauld Institute Galleries, London

42 PAUL GAUGUIN, *Seaweed Harvesting*, 1889. Oil on canvas, 87.5 × 123 (34$\frac{1}{2}$ × 48$\frac{3}{4}$). Folkwang Museum, Essen

43 EMILE BERNARD, *The Buckwheat Harvest*, 1888. Oil on canvas, 72 × 92 (28$\frac{3}{8}$ × 36$\frac{1}{4}$). Josefowitz Collection

44 PAUL GAUGUIN, *The Man with an Axe*, 1891. Oil on canvas, 92 × 70 (36$\frac{1}{4}$ × 27$\frac{1}{2}$). Private collection. Courtesy of Ellen Melas Kyriazi

45 PAUL GAUGUIN, *Gathering Fruit in Martinique*, 1887. Oil on canvas, 89 × 116 (35 × 45$\frac{1}{2}$). Vincent van Gogh Foundation/Van Gogh Museum, Amsterdam

46 Photograph of the Palais des Colonies at the Universal Exhibition, Paris, 1889. From E. Monod, *Livre d'Or de l'Exposition Universelle, Album*, 1890

47 PAUL GAUGUIN, *Bonjour, Monsieur Gauguin*, 1889. Oil on canvas, 113 × 92 (44$\frac{1}{2}$ × 36$\frac{1}{4}$). National Gallery, Prague

48 EDGAR DEGAS, *Nude Woman Lying on a Sofa*, 1885. Pastel on monotype. Location unknown

49 PAUL GAUGUIN, *Nevermore, O Tahiti*, 1897. Oil on canvas, 60 × 116 (23$\frac{5}{8}$ × 45$\frac{5}{8}$). Courtauld Institute Galleries, London

50 PAUL GAUGUIN, Page 57 of the Louvre manuscript of *Noa Noa* with woodcut of Hina and Tefatoua from *Te Atua*, photograph and watercolour. Cabinet des Dessins, Musée du Louvre. Photo Réunion des musées nationaux